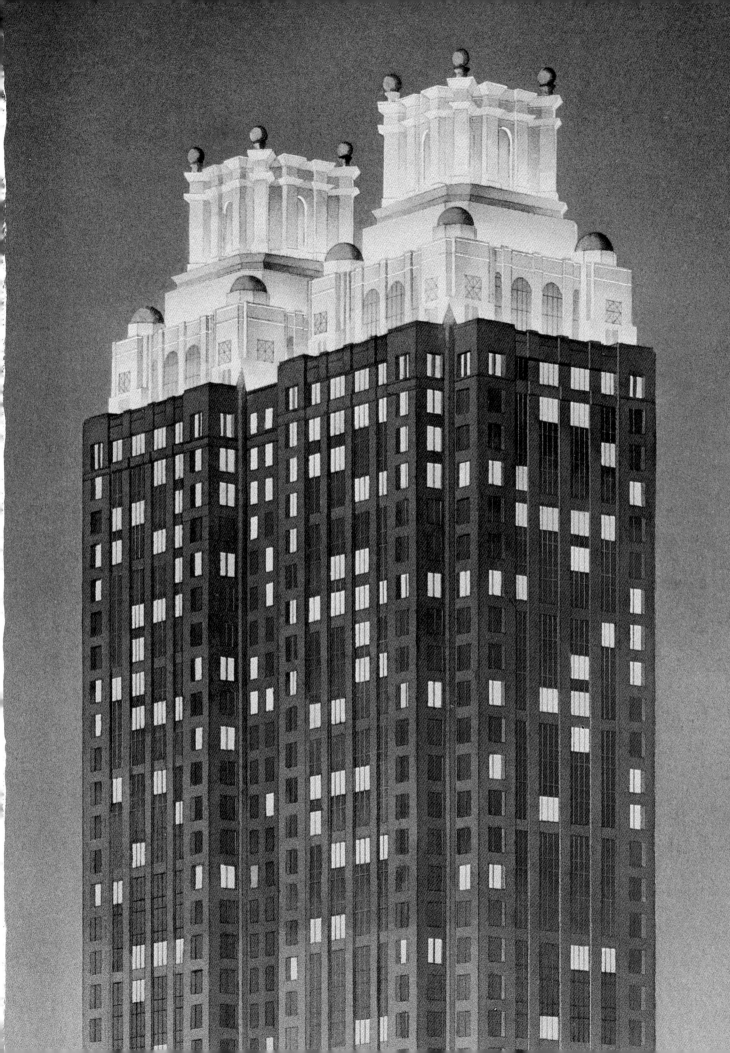

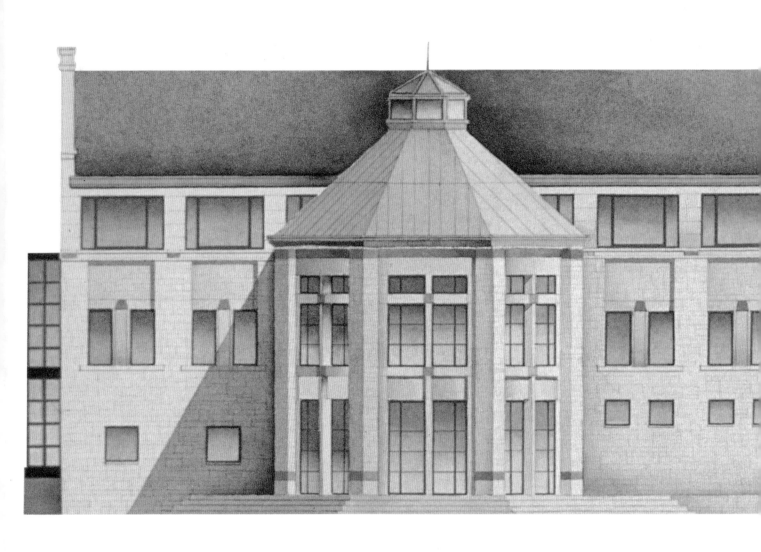

ARCHITECTURAL ILLUSTRATION IN WATERCOLOR

STEPHAN HOFFPAUIR AND JOYCE ROSNER

WHITNEY LIBRARY OF DESIGN
an imprint of Watson-Guptill Publications/New York

We wish to acknowledge the following individuals:

Julia Moore for her support and direction;

Le Melcher for his legal assistance;

Maureen Gordon and Numae Blevins for typing;

Madelyn Stahl Bolt of The Slide Studio and Ray Burnette
of Aker/Burnette Photography, Inc. for photography;

Scott Ballard, John Fogarty, Sally Walsh,
and Anna Wingfield for their help and encouragement;

Cornelia Guest, Glorya Hale, and Peter Rocheleau
of the Whitney Library of Design.

Our greatest thanks goes to all of our clients
without whose support this book would not be possible.

Additional credits

Pages 2–3: Cody Memorial Library Addition and
Renovation, Southwestern University, Georgetown, Texas;
Skidmore, Owings & Merrill, architect.

Page 5: Elevator Door Study,
Sun Bank Center, Orlando, Florida;
Skidmore, Owings & Merrill, architect.

Pages 6–7: NBW Center, Washington, D.C.;
Shalom Baranes Associates Architects, architect.

Page 8: Renaissance Tower, Dallas, Texas;
Skidmore, Owings & Merrill, architect.

First published in New York by Whitney Library of Design
an imprint of Watson-Guptill Publications
a division of Billboard Publications, Inc.
1515 Broadway, New York, NY 10036

Library of Congress Cataloging-in-Publication Data
Hoffpauir, Stephan.
 Architectural illustration in watercolor.

 Bibliography: p.
 Includes index.
 1. Architectural drawing—Technique. 2. Watercolor
painting—Technique. I. Rosner, Joyce. II. Title.
NA2726.5.H64 1989 720'.28'4 89-5817
ISBN 0-8230-0247-0

Manufactured in Singapore
First printing, 1989
1 2 3 4 5 6 7 8 9 / 94 93 92 91 90 89

To my parents Jerry Rosner and Florence Protetch Rosner

To my grandparents Will Hoffpauir and Lily Moulière Hoffpauir

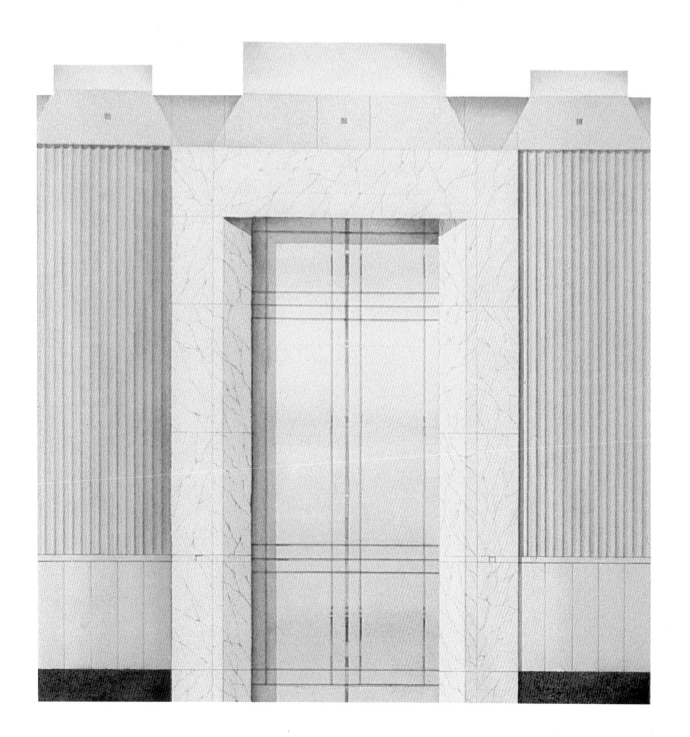

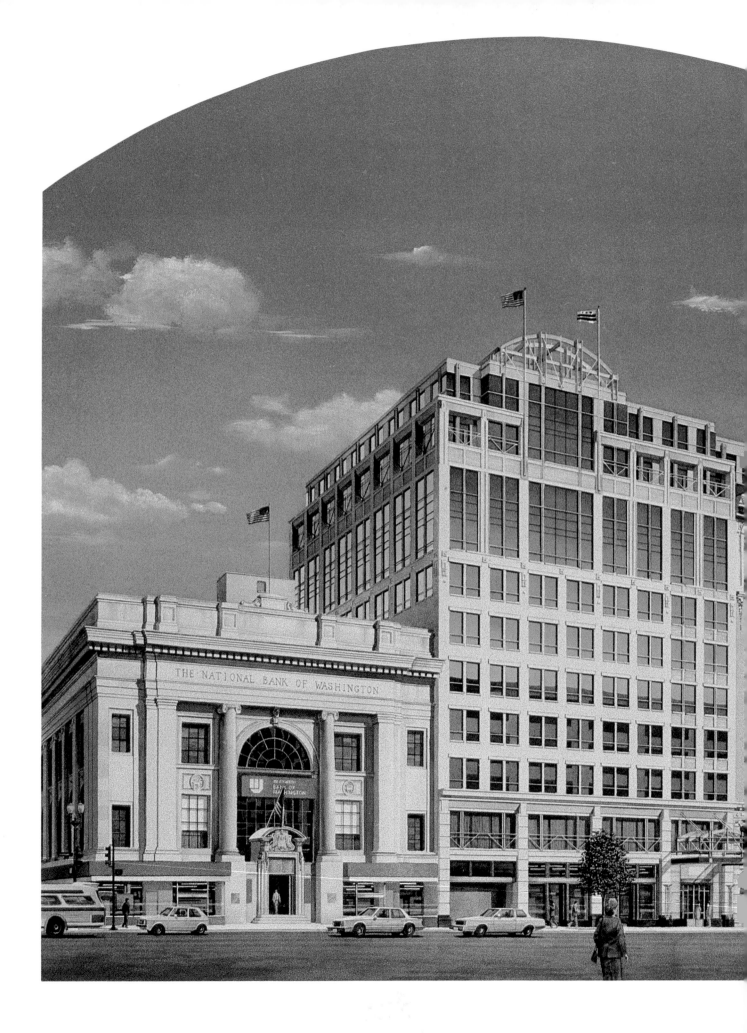

CONTENTS

PREFACE

WE HAVE both always been interested in watercolor as a painting/drawing medium. Whether reading art history accounts of famous watercolorists or instructional books on the subject, we have always found that the authors of these books extolled watercolor as a medium suited to the fast, spontaneously impressionistic sketch, the broad stroke unfettered by distracting detail. Watercolor *by nature* was a medium ill-suited to complex and detailed pictorial descriptions. Trying to use it in this way, one risked unfavorable comparisons to oil painting. This view, about what was and was not possible with this medium, paralleled nicely with the modernist architectural doctrine of "truth of materials."

We accepted this notion until 1983, when we saw an exhibition sponsored by the Museum of Fine Arts—Houston of nineteenth-century student drawings from the École des Beaux-Arts in Paris. We were spellbound. Here were drawings so precise, so assured, that watercolor was actually used as a *drafting* medium—with colors so deep and rich you could almost drown in them.

We were intrigued. If mere students could do this, then surely so could we. What followed was a five-year period of experimentation to teach ourselves how to emulate these drawings. Of the many instructional books on watercolor then in print, none dealt with the subject of architectural drawings. The books available to us were helpful only insofar as they discussed the basic rudiments of watercolor painting. It was obvious to us that—if we were going to learn to do this—we would have to teach ourselves.

This book outlines what we learned during that period. It is designed for those architects, interior designers, students, illustrators, and artists who want to produce architectural drawings in watercolor, but do not want to spend five years learning how. It is assumed that the readers are already well versed in the language of orthogonal projection and perspective drawing. For these people, this book gives all of the necessary information to produce competent and—one hopes—beautiful drawings in watercolor.

Of course, you cannot really duplicate the drawings of another era anymore than one can duplicate its buildings. It is probable that the drawing tools, techniques, and raw materials have changed; it is certain that the architecture has changed. You must adapt and reinterpret the conventions of another age if they are to have meaning for this one. In our own work, we have tried to evolve a type of architectural drawing that is both dreamlike and allegorical, and have included some examples in this book.

This book is different from others on the subject of watercolor in that there are very few loose or sketchy drawings shown. There are many excellent books with fine examples of this type of drawing, so we saw no need to write one more. The examples in this book are primarily very detailed, high-resolution drawings, which is our particular interest. We fully realize that not everyone will have the inclination or the time necessary to execute such drawings; however, that is unimportant. What we have done is to lay down basic principles, as well as detailed instructions, which can be adapted to suit your personal style and needs.

It goes without saying that, no matter how good a book on this subject may be, you will not become proficient by reading alone. You must pick up a brush and start to paint. We hope you will be encouraged knowing that neither of us has had any formal training in painting or watercolor. We mention this in all modesty in the hopes of dispelling the notion—all too common among design professionals—that watercolor is a difficult medium in which to work. Anything is difficult if you do not know the basic rules. We hope that in laying down these rules, we will provide a book that you will eventually outgrow. When you have learned to break the rules, you will have achieved mastery and developed your own personal approach to watercolor.

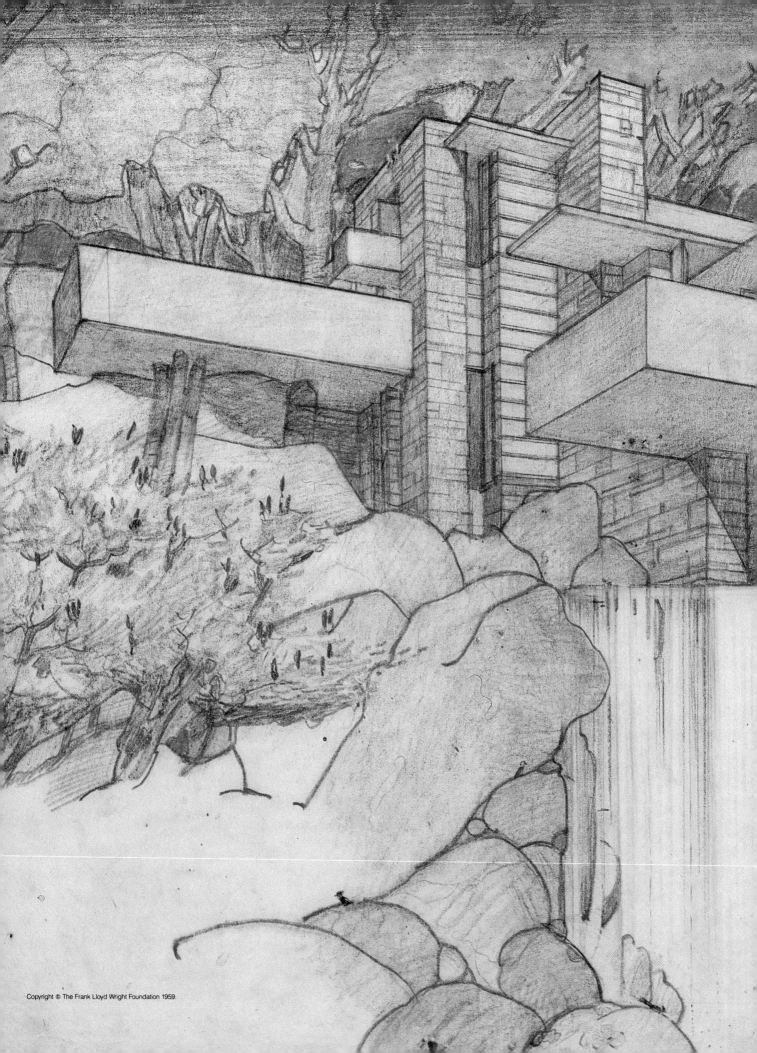

HISTORY
AND
THEORY

1. HISTORY

WATERCOLOR is a water-soluble painting medium made up of ground pigments bound by gum arabic, a product of the acacia tree. Water is used as the solvent to thin and dilute the medium the way turpentine or mineral spirits are used for oil paints.[1]

Although not used as a medium for masterpieces of art in Western countries until the eighteenth century, water-based pigments have been employed for many centuries. Some pigments, such as carbon black, yellow and red ochre, and the iron oxides, date from the Neolithic period and are still in use today. The ancient Romans also discovered a number of pigments; among those currently in use, lead white, terre verte, and madder lake are their inventions.[2] Water-soluble paints were also used by such diverse ancient peoples as the Chinese, the Egyptians, and the Assyrians, as well as by Europeans of the Middle Ages.[3]

In spite of the long history of use of water-based paints, the greatest technological innovations in the medium took place in the eighteenth and nineteenth centuries.[4] Probably no country is more closely associated with the art of watercolor painting than England, and so it is not surprising to find that many of the greatest technological improvements in the medium, in paper, and in brushes took place in that country. Well into the eighteenth century, it was customary for watercolorists to mix their own colors using dried pigments purchased in apothecaries. It was not until the 1780s, in England, that one could buy ready-made watercolors. This was made possible by the invention of watercolor cakes by William and Thomas Reeves. This invention was soon being packaged into complete, self-contained mahogany kits containing brushes, porcelain trays for mixing, a glass for water, and lead pencils. In the 1830s, the firm of Winsor & Newton introduced a series of moister colors packaged in small trays, and a tin watercolor box, introduced by the same firm in 1853, was purchased by eleven million would-be colorists.[5]

In spite of the growing availability of commercially prepared colors, professional artists continued to mix their own, and even to look for new pigments and mixtures. The artist John Varley experimented by adding gin and honey to his pigments, in an effort to create an effect resembling a

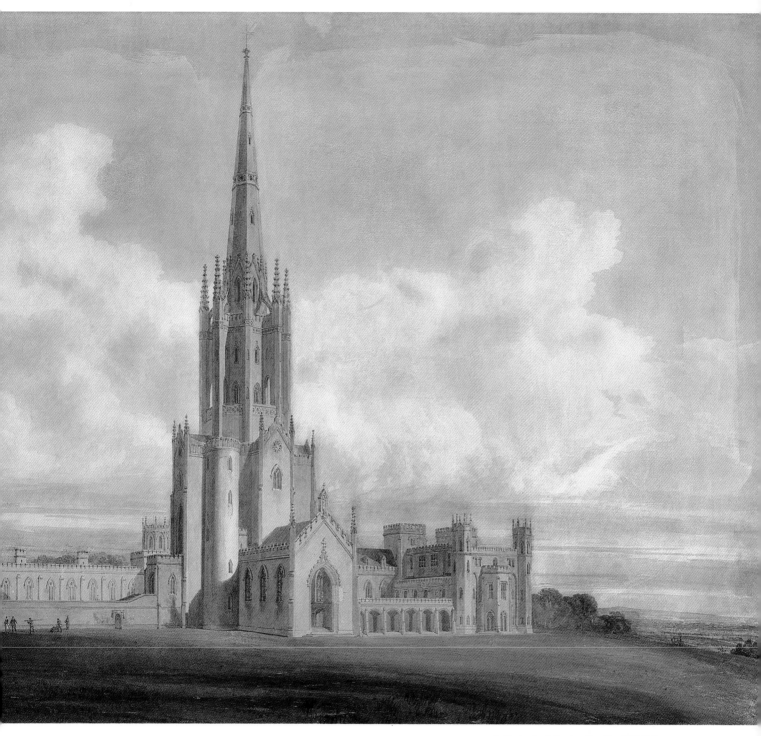

A Projected Design for Fonthill Abbey, Wiltshire, by artists James Wyatt (1746–1813) and J. M. W. Turner (1775–1851). Used by permission of the Yale Center for British Art, Paul Mellon Collection.

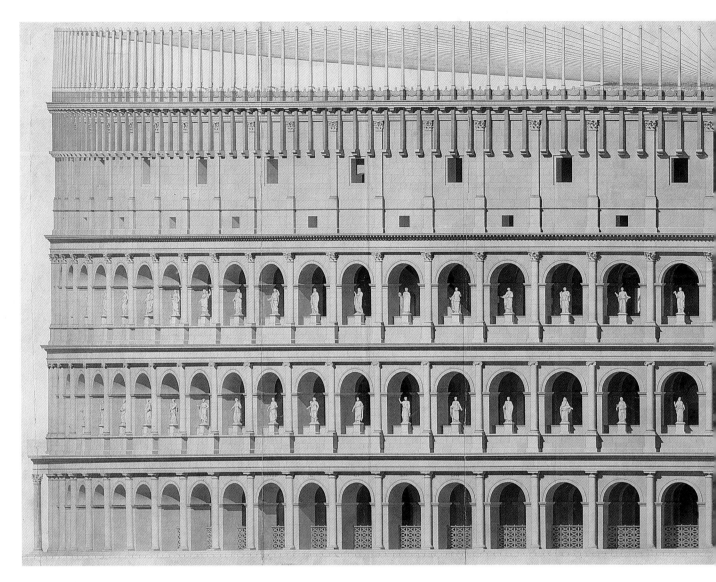

Watercolor elevation of the Colosseum, Rome, by Louis Joseph Duc, 1829. Used by permission of École Nationale Supérieure des Beaux-Arts, Paris.

varnished oil painting. Paul Sandby created new shades of gray from burnt bread and split peas.[6] An experiment with more lasting results was made by William Payne when he combined alizarin crimson, lamp black, prussian blue, and ultramarine to create Payne's gray.[7]

The technology of papermaking also improved greatly during this period. Until the mid-eighteenth century the best papers had been produced in France, Germany, the Netherlands, and Italy. A bit later, these papers, as well as the linen rags used to make them, came into short supply in England owing to disruptions in trade caused by the French Revolution and the Napoleonic Wars. Ultimately, experiments to find acceptable alternatives for the scarce linen rags were undertaken. Such unlikely materials as asparagus stalks,

jute, turf, and leather were tried before esparto grass and wood pulp became the substitutes of choice.[8]

Another important breakthrough in paper technology came in 1756 when James Whatman introduced wove paper. Whatman produced this paper by drying pulp in a new kind of mold made of fine wire mesh, which resulted in paper with a uniform surface texture. Previously pulp had been dried in molds made of parallel lines, or chains, giving the resulting paper noticeable watermarks across its entire surface. Because of the astute salesmanship of Whatman's son, wove paper was in wide use within twenty years after its introduction.[9]

Historically, watercolor was a tool used by draftsmen, such as cartographers and topographers, and it was occasionally used by artists to make visual notes and memoranda of

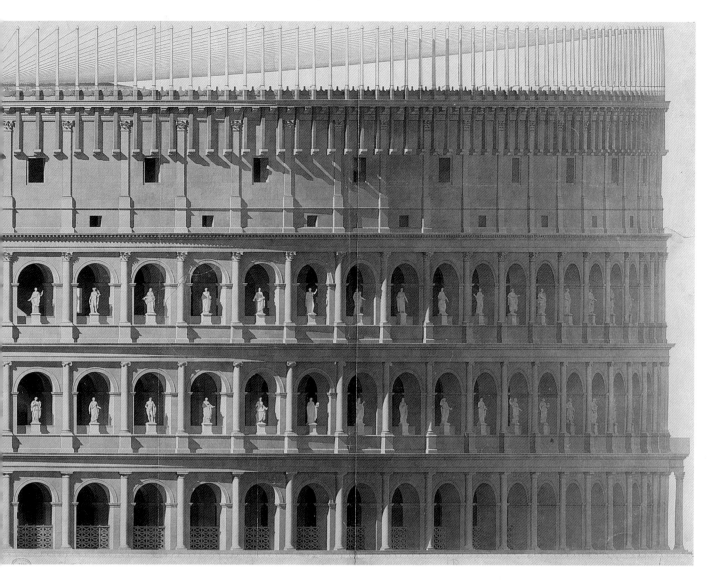

observations. It was applied in thin washes, always over a pencil or ink line drawing, and it did little more than tint or stain the paper.[10] Architects occasionally made timid use of watercolor in the eighteenth century. In drawings of elevations, Andrea Palladio would sometimes differentiate wall planes by lightly washing those in the background to indicate that they receded. Voids in a wall would be washed with a slightly darker tone, to indicate windows and doors. Portions of a drawing would be washed in graded tones to make a dome or a barrel vault appear more legible. Since Palladio's drawings never employed perspective, the watercolor washes, which were always subservient to line, were used diagrammatically to differentiate one plane from another.[11]

It is useful to differentiate between two types of architectural drawings: orthogonal drawings and perspectives. Orthogonal drawings include Palladio's drawings: plans, sections, and elevations. They are in essence diagrams intended to give objective information about a particular building or portions thereof and are drawn according to unvarying rules. They are not representations of buildings as would be seen in nature. For example, an elevation will show all exposed vertical planes facing, say, in a northerly direction. Looking at one side of a faraway building through a telescopic lens will approximate looking at its elevation. No horizontal plane will be shown in the drawing, nor will planes facing any direction but north. And unless shadows are present, there will be no indication of which planes are in the foreground and which are in the background. Ortho-

gonal watercolor drawings became closely associated during the nineteenth century with the École des Beaux-Arts, in Paris, about which more will be discussed later.

A perspective is a drawing showing three dimensions, set up according to the rules of perspective discovered in Italy during the fifteenth century by Filippo Brunelleschi.[12] An accurate perspective drawing will be representative of a building as it would appear to the human eye, or, more precisely, to a camera's lens. All horizontal lines will "vanish" to one or more invisible points on the horizon. All vertical lines will appear vertical and will be parallel to each other. Curiously, although Leon Battista Alberti codified the laws of perspective in his book of 1436, *Della Pittura*, he urged against the use of perspective by architects, believing it could be misleading, and

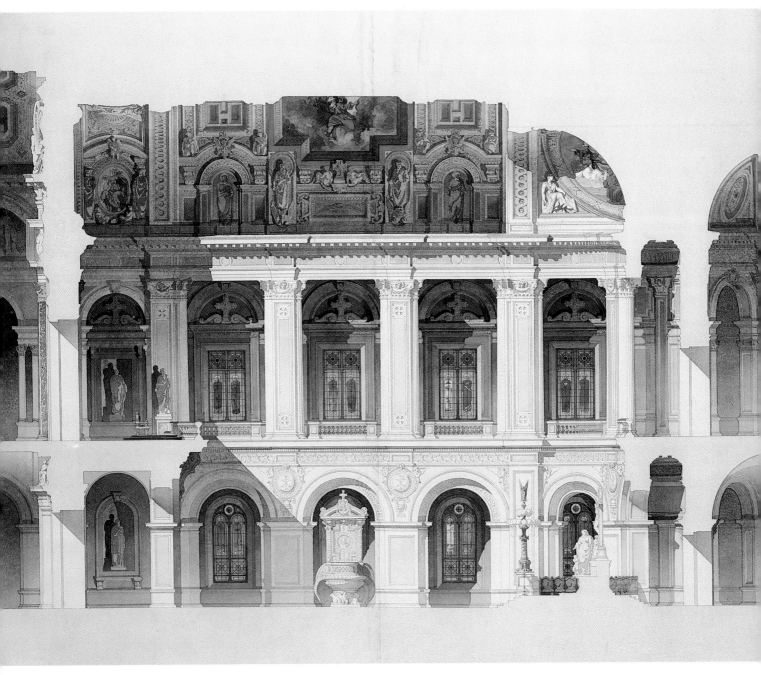

*L'Escalier principal d'un palais
d'un Souverain*, by Emmanuel Brune.
1863 Prix de Rome. Used by permission
of École Nationale Supérieure
des Beaux-Arts, Paris.

recommended instead the use of plans and models to represent unbuilt projects. [13]

Although the laws of perspective are no less precise than those of orthogonal drawings, they have over centuries proven to be particularly susceptible to dilution by way of "artistic license." Depending on one's point of view, herein lies either their greatest strength (flexibility) or greatest weakness.

Looking at nineteenth-century examples it is easy to associate perspective drawings with England and orthogonal drawings with France, but this has not always been correct. The seventeenth-century English architect Inigo Jones acquired Palladio's famous 1570 treatise, *I Quattro Libri dell'Architettura*, which Palladio, following Alberti's dictum, had illustrated using only orthogonal methods. Inigo Jones followed suit, and for some time thereafter this convention dominated English architectural drawing. The convention lasted well into the time of Sir Christopher Wren, who used plans and models to convey how his finished buildings would look, and commissioned perspective drawings only after the constructed works were complete. [14] English Neo-Palladians of the eighteenth century, however, were much more adept at representing three-dimensionality in their drawings than their namesake had been. They had learned the effectiveness of rendering shadows in elevations with watercolor washes; elements would be shown advancing or receding from the main facade of a building. A shadow of a portico falling across a building's face is a notable example of this technique. [15]

This is not to say that the English were unaware of the rules of perspective during this time. Books on perspective began arriving from Italy in the early 1700s and were either translated into English or printed in Italian. The first of this kind was Andrea Pozzo's *Perspectiva pictorum et architectorum*, translated and published in 1715 under the title *Linear Perspective*. Other books followed, but it was not architects who first put their principles to work—it was topographical and landscape artists. [16]

A topographical drawing is a perspective drawing of a building that already exists, as opposed to what has become known as a rendering, which is a drawing of a structure not yet built. [17] The English watercolor tradition is replete with topographical drawings. The English have a particularly rich legacy in this genre, and without it the craft of the architectural perspective would be much the weaker, if not nonexistent.

In the beginning of the eighteenth century, the English aristocracy had a great deal of discretionary income. They were interested in portraits of their possessions, the bulk of which were their large estates. [18] They engaged topographical artists to do drawings in ink, with delicate watercolor washes laid on top. [19] This formalistic approach then changed drastically with the appearance of two young artists: Thomas Girtin and J. M. W. Turner.

During the last quarter of the eighteenth century, Girtin and Turner worked for a Dr. Thomas Monro doing topographical drawings for *Walker's Magazine*. Girtin would do the line drawings in ink and Turner would tint them with gray and other colored watercolor washes. [20] From this modest start the two artists would increasingly introduce and refine the latest developments in watercolor technique. Up to this point, the custom had been to do a monochrome underpainting, indicating all light and dark areas in gray, and to apply colored tints on top. Girtin and Turner eliminated the gray underpainting and used a variety of colors to indicate shadow areas, and thereby heightened the intensity of all their hues. [21]

Although Girtin is remembered for his innovative use of color, he rarely used more than six or seven colors in a single drawing. However, he made the most of those he did use. He usually laid in the sky first, using a much bolder blue than had traditionally been used. He made gray tones not from black, but from color combinations, Venetian red and indigo, for example. For shadows he used warm sepia or burnt umber, rather than cold gray or india ink. His greens were combinations of gam-

bouge, indigo, and burnt sienna. He was the first to see a tree as a mass of light and dark regions rather than a collection of leaves. [22] Girtin would likely have achieved much more, both technically and artistically, had he not died at the age of twenty-seven, from asthma and bronchitis. [23]

Turner, on the other hand, went on to become not only one of the most important watercolorists England has ever produced, but also one of the great landscape painters in the history of Western art. He used every new technique at his disposal to create works of great beauty. Turner primed his paper with a gray wash, over which he laid bodycolor, a type of opaque watercolor made by mixing traditional watercolors with Chinese white. This has given some of his watercolors a slight opacity reminiscent of pastels. He created light areas in his washes by lifting out color with a wet brush, a dry cloth, or even pieces of bread. He would also lift out color by scraping the dry paper with a knife, or create highlights by using white chalk on top of the watercolors. Turner worked very rapidly and was one of the first watercolorists to use the wet-into-wet technique to represent clouds. Later in life Turner ceased tinting his papers and using bodycolor, and his works on paper became even more luminous and transparent, an effect he tried to translate into his oil paintings. These qualities, transparency and luminosity, are particularly apparent in the spectacular oil paintings of Venice he did in his later years, in which the city and the sea seem nothing more than beautiful, illuminated vapors. [24]

Girtin and Turner were probably the greatest among a long succession of topographical painters. Their contributions influenced greatly the development of architectural drawings in watercolor. The great landscape designer Lancelot "Capability" Brown drew on their legacy of watercolor perspectives and used this inspiration to communicate to his clients what his design intentions were. Brown's drawings were retained by his clients, after completion of projects, as mementos. [25] Perspective drawings began to be used by architects in England in the 1770s, and reached new

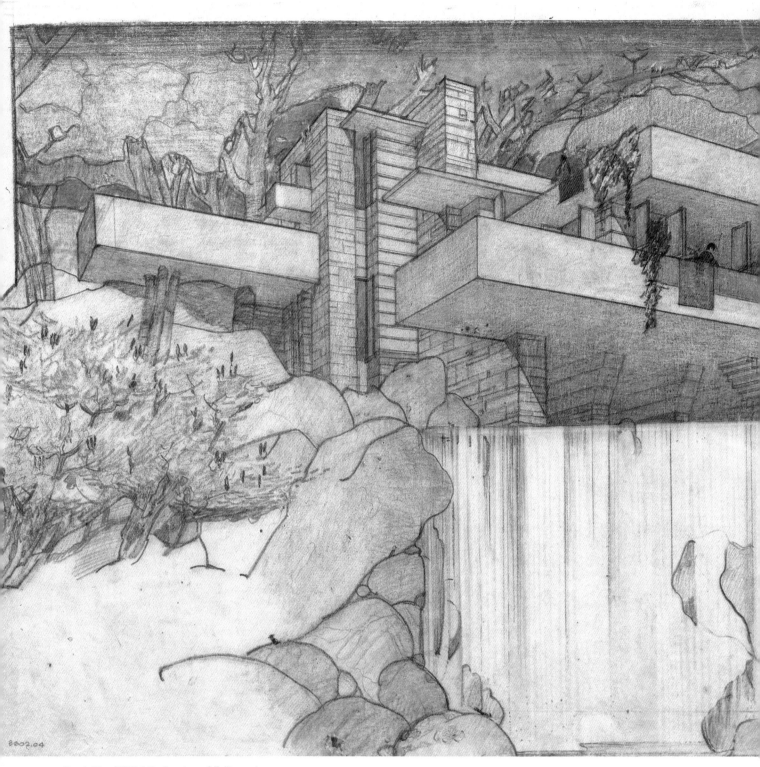

Frank Lloyd Wright's drawing of Fallingwater.
Copyright © The Frank Lloyd Wright
Foundation 1959. Used by permission of
The Frank Lloyd Wright Archives.

heights in the nineteenth century in the works of Joseph Michael Gandy.[26]

Gandy, an architect by training, was employed periodically by Sir John Soane to create perspective drawings of his unbuilt projects. Many of these survive and are housed in the Soane Museum in London. Notable among them are those depicting a design for the Bank of England and a classically inspired design for the Houses of Parliament. Because so many of Soane's projects were either never built or destroyed, Gandy's drawings are vital documents, necessary to the understanding of the work of this important architect. Gandy received recognition in his own right as an architectural fantasist, creating remarkable visions of other-worldly palaces and monuments in the tradition of Giambattista Piranesi, Étienne-Louis Boullée, and Antonio Sant'Elia.[27] Gandy was not, however, without his creative faults, for although he was an accomplished watercolorist, as a perspectivist he was somewhat lacking. He seems not to have fully understood the phenomenon of foreshortening, as his buildings often appear to be unnaturally elongated.

As the nineteenth century wore on, technical prowess with watercolor became a trait highly valued in topographical painters. Chromas became much more intense, and greater attention was being paid to detail.[28] The same characteristics can be seen in architectural drawings of the period. In late nineteenth-century England, architectural competitions proliferated, and watercolor perspectivists were in great demand by architects who used their services to help garner sought-after competition prizes.[29] There were individuals who felt that perspective drawings should be prohibited from competition submissions on the grounds that buildings could be unduly romanticized and that perspective drawings, therefore, were inherently dishonest. For examples of what they had in mind, the opponents of perspective drawings pointed to the École des Beaux-Arts. There was pressure to impose greater standardization in drawing.[30]

To understand the role drawings played at the École, it is necessary

to understand how academic life was structured there. The École des Beaux-Arts was established in 1819 to replace the Académie Royale d'Architecture. Its academic doctrine glorified reason, a concept that grew out of the French Enlightenment. Students learned by making observations of classical antiquity and were encouraged to think logically.[31] The École evaluated its students through a series of *concours*, or competitions. These were of two types: the *esquisse*, a sketch competition lasting twelve hours, and the *projet rendu*, a more elaborate sketch competition taking up as much as six months of a student's time.[32] Advancement was predicated on doing well in a certain number of *concours*. The most advanced students vied for the *Grand Prix de Rome*, the winner of which was permitted to study at the French Academy in Rome, at government expense.[33] Once there, a student was required to send back an analytical study of a major classical building, and then later a hypothetical reconstruction of that building. These submissions were known as *envois*, the word actually meaning "something sent," and were preserved in the school's archives.[34]

The École's didactic role was quite circumscribed, and consisted of lecturing, issuing design assignments, and judging *concours*. Curiously, the teaching of design did not take place at the school, but in private *ateliers*, or studios, organized by students themselves, each one headed by a *patron*, an architect who more than likely had been a former *Grand Prix* winner. A young student entering an *atelier* received guidance and instruction from older students, in exchange for which he assisted in the preparation of drawings for his elder colleagues' *projets rendus*.[35] This was a most difficult task, given the complexity of many of these drawings and the fact that some would be as long as twenty-six feet.[36]

Both the submissions for the *Grand Prix* as well as the *envois* were put on public display, and the exhibitions of these works were considered major social events followed by both the press and the public.[37]

In any competition or exhibition situation a drawing's ability to explain clearly, and perhaps even more importantly, *to seduce* becomes essential. In an academic program founded on competition it should not be surprising that drawings of the most astonishing precision, clarity, and beauty were produced in abundance.

Following their rationalist precepts, students at the École produced orthogonal drawings in watercolor that, although changing in style and technique over time, always followed a fixed set of conventions. Of the three types of orthogonal drawings (plans, building sections, and elevations), plans were the simplest and most diagrammatic. They tended to focus on the disposition of columns and walls, and dealt to a lesser extent with paving patterns. Structural elements such as columns were rendered in solid black, and there was little or no effort made to indicate building materials or shadows.

Structural elements in sections, on the other hand, were rendered with the palest pink or gray washes. One of the functions of the section was to indicate the elaborate surface ornamentation of the interior spaces, so the pale section cuts contrasted well with the more intense chromas of the walls beyond. Shadows were indicated, not as you would see them if you were standing inside one of the interior spaces, but as though you were standing outside a pulled-apart dollhouse looking in. On curved surfaces such as domes and barrel vaults the shadows got lighter rather than darker as a surface curved around, indicating that these artists understood very well the effects of reflected light.

In both sections and elevations, light and shadow defined form. The French were, at least in terms of architectural drawings, the absolute masters of the graded wash, and their drawings capture the qualities of direct and reflected light. On flat vertical surfaces, shadows grade darker as they approach their source. In elevations, voids for windows grade dark to light from top to bottom, suggesting the shimmering quality of glass. Graded washes are particularly striking when they occur over a highly ornamented surface, a technically difficult and a time-consuming effect that can only be achieved by the slow build-up of wash upon wash. As light and shadow become more important, line becomes irrelevant. So well did these student artists understand the concept of color contrast that, in most cases, ink or pencil lines could be eliminated with no loss of clarity.

The reason these drawings are so striking to contemporary viewers is that the medium of watercolor is manipulated in a way foreign to modern usage. Whereas today watercolor is considered a loose and sketchy medium, these drawings are precise and tightly controlled. Whereas watercolors are expected to be soft and vaporous, these chromas are deep and lush. And whereas watercolors are commonly perceived as having been produced quickly and in a small format, here are immense works over which teams of people have labored for months. To look at these drawings with contemporary eyes is to rediscover the enormous possibilities of the medium.

During the period of the American Revolution, the French tradition of architectural drawing made its presence felt particularly strongly in the United States. The country's political ties with France were especially strong during this period, and its first trained architects were French. A French military officer, Pierre Charles L'Enfant, laid out the plan for Washington, D.C.,[38] and a French architect, Étienne Hallet, won a competition to design the U.S. Capitol.[39] Thomas Jefferson, once an ambassador to France, produced orthogonal watercolor drawings for his design of the University of Virginia.[40] American architect Benjamin Henry Latrobe's drawings of the President's House and the extension to the U.S. Capitol are nearly as fine as any drawings from the École des Beaux-Arts of the nineteenth century.[41]

The theories and drawing techniques of the École des Beaux-Arts became increasingly important in the United States as the nineteenth century progressed. The first American to enroll at the École was Richard Morris Hunt, in 1846. Over five hundred of his compatriots studied there from 1846 to 1968, including Charles McKim, later a partner in the firm of

McKim, Mead & White.[42] Like other American firms influenced by the École des Beaux-Arts, McKim, Mead & White employed a number of artists to create watercolor perspectives in the English tradition, as well as the usual orthogonal drawings. These perspective drawings were especially important to the large-scale public projects with which the firm was involved, as the drawings had to communicate the firm's design intentions to large numbers of people who had not had a rigorous classical education, and for whom plans and elevations might have been somewhat hard to understand.

Beginning in the late nineteenth century and continuing into the twentieth, U.S. architects employed perspective drawings with greater and greater frequency. With regard to architectural drawings done in watercolor, the trend had been for line to become less important and for color to become more important. At the turn of the century, this trend was reversing. This is nowhere more evident than in the drawings of Frank Lloyd Wright. Like a number of Austrian secessionists, such as Otto Wagner, with whose work Wright's early work is sometimes stylistically grouped, Wright used watercolor on top of what were essentially ink or pencil line drawings. Color was applied in large flat washes. Although color clarifies the drawings, it is usually not essential to the understanding of the drawings. Wright was liberal in his choice of media and in addition to watercolor would often use gouache, colored pencil, or colored inks in the same drawing.

Watercolor was a frequent medium for architectural drawings until World War II. Although we associate Hugh Ferris' dramatic black and white charcoal renderings of New York skyscrapers with the 1930s, a number of perspectivists were continuing to work in watercolor during the decade. Prominent among them was John Wenrich, who delineated a number of New York's famous high rises, the most noteworthy being the Rockefeller Center buildings.[43] Although not as dramatic as Ferris' chiaroscuro visions, Wenrich's drawings convey a sense of ethereality—

of buildings seen through the vaporous haze of a celestial city. The sense of mysticism as well as the perception that a building is melting into light and air is not unlike feelings evoked by the later work of J. M. W. Turner.

After World War II the use of watercolor as a medium for architectural drawings became virtually nonexistent. When it was used at all, it was generally in conjunction with an airbrush or as opaque watercolor (also known as gouache). Gouache became popular because of its correctability. Although watercolor can be manipulated to achieve a variety of effects, it is very unforgiving. Once the color is laid down it is difficult, if not impossible, to remove or paint over it. Gouache, because of its opacity, allows the artist to paint over his or her mistakes and misjudgments. However, also because of their opacity, gouache colors lack the subtlety and tonal variety of watercolor and thus drawings done in the medium can look flat.

During the postwar period, interest in architectural drawings and, thus, their quality declined markedly. Technology had changed the building materials themselves. By building glass architectural models, Mies van der Rohe discovered that it was the play of reflection, and not light and shadow, that defined architectural form.[44] Without the traditional form determinants, traditional drawing media and techniques seemed irrelevant. The effect of this on perspective drawing was the creation of a state of comfortable mediocrity, as drawing became very formulistic.

This began to change in 1975 when the Museum of Modern Art in New York, in conjunction with the École des Beaux-Arts, mounted an exhibition of nineteenth-century architectural drawings by students at the École. This was followed in 1983 by an exhibition entitled "Paris-Rome-Athens: Travels in Greece by French Architects in the 19th and 20th Centuries," representing a collection of drawings by students of the French Academy in Rome. These and subsequent exhibitions of historic English and American drawings occurred at a time when modernist precepts were increasingly being called

into question. Suddenly, architects became aware again of the power of drawing, and of the potential and versatility of watercolor as a drawing medium.

Today, a growing number of architectural firms, some of them quite noteworthy, are beginning to use watercolor drawings as a design and presentation tool. Although some firms hire freelance watercolor perspectivists for important presentation drawings, others have draftsmen on their staffs who use watercolor rather than colored markers or pencils to produce their drawings. This is, however, not a widespread practice. Many of the old skills have been lost or forgotten and must be learned by a new generation of architects. It is to this deficit that this book is addressed.

Notes

1–9. H. L. Mallalieu, *Understanding Watercolors* (Woodbridge, Suffolk, England: Antique Collector's Club, 1985), 15, 28–34, 36–37, 44.

10. Scott Wilcox, *British Watercolors: Drawings of the 18th and 19th Centuries from the Yale Center for British Art*, (New York: Hudson Hills Press in association with the Yale Center for British Art and the American Federation of Arts, 1985), 9–10.

11–15. Jill Lever and Margaret Richardson, *The Architect as Artist* (New York: Rizzoli, 1984), 7, 18–20.

16. Gavin Stamp, *The Great Perspectivists* (New York: Rizzoli in association with the Royal Institute of British Architects Drawing Collection, 1982), 9–10.

17. Ibid., 9.

18. Mallalieu, p. 49.

19. Stamp, p. 12.

20–24. Martin Hardie, *Watercolor Painting in Britain: The Romantic Period*, Vol. 2, edited by Dudley Smelgrove with Jonathan Mayne and Basil Taylor (New York: Barnes & Noble, Inc., 1967), 5–6, 10, 13–18, 27–41.

25. Mallalieu, 49.

26. Lever and Richardson, 19.

27. Ibid., 8, 17.

28. Wilcox, 16.

29. Stamp, 14.

30. Ibid., 18.

31–37. Arthur Drexler, ed., *The Architecture of the Ecole des Beaux-Arts*, essays by Richard Chafee, Arthur Drexler, Neil Levine, David Van Zanten (New York: The Museum of Modern Art, distributed by the MIT Press, 1977), 61–63, 65, 83, 86–92.

38. Bates Lowry, *Building a National Image: Architectural Drawings for the American Democracy, 1789–1912* (New York: Walker, 1985), 13–15.

39. Deborah Nevins and Robert A. M. Stern, *The Architect's Eye: American Architectural Drawings from 1799–1978* (New York, Pantheon, 1979), 30–31.

40. Ibid., 44–47.

41. Lowry, 93–99.

42. Drexler, 464.

43. Nevins and Stern, 126.

44. Drexler, 24.

2. COLOR THEORY

THROUGH PRACTICE and experimentation, as well as through the study of art history, your knowledge of and sensitivity to color may be greatly increased. Two of the most well-known color theorists of the early 1900s are Johannes Itten and Albert Munsell. Their studies and ideas will be helpful to anyone dealing with color.

Throughout human history, color has been used in many different ways. The early Greeks and Egyptians, as well as the Chinese, were very accomplished colorists. One can survey the history of art, from the early Roman mosaics to the works of such cubist painters as Picasso and Braque, to learn about the various attitudes toward the use of color.

When discussing the uses of color, it is helpful to understand the vocabulary Munsell developed in his system for organizing and characterizing colors. He defined three "qualities" of color: *hue*, *value*, and *chroma*, any one of which may be altered without affecting either of the others. The first quality, hue, classifies a color. For example, red, blue, and yellow are hues. The second quality, value, denotes the "relative lightness" of a color. Lighter colors or hues are referred to as being light in value; darker hues are dark in value. The third quality, chroma, is the intensity of a color. As Munsell stated in his book *A Color Notation*, chroma "distinguishes a strong color from a weak color."

When mixing pigments it is important to realize that colors can change simultaneously in all three aspects. Thus, adding one color to another may not only change the value and intensity of the original color, but also the hue. A simple example would be to add light red to blue. The addition would not only change the value and intensity of the original blue, but the hue as well—for it would no longer be blue, but instead purple.

Itten extensively researched the interactions of color, studying such issues as the saturation of colors, spatial effects of colors, shadows, and color composition. Saturation, similar to chroma, deals with the "purity" of a color. There are many ways to dilute a color, some of which are more appropriate than others when working with watercolor. When you dilute a pure color, such as yellow, with white, the resulting color appears cooler. However, when you dilute a color with black, instead of becoming cooler, the color is deadened and becomes very unappealing; again, yellow is a good example. White is an opaque pigment, however, and it is used principally to make opaque watercolors rather than to lighten colors. An opaque watercolor would be used to draw light window mullions on a dark glass surface, for instance. And, because black and gray do, in fact, deaden a pure color, we use other methods of "graying" a color, such as adding its complementary color. Thus, if we need a red to be less intense and duller, we add its complement, green.

To determine a color's complement, look at a color wheel. Colors directly opposite each other on the wheel are called complementary colors. When complementary colors are mixed, they produce gray. Ultramarine blue and burnt umber represent a common example of this phenomenon. Alizarin crimson and Hooker's green also complement each other. When not mixed together, but placed side by side, complementary colors look their most intense. This is a useful fact to keep in mind when choosing a color scheme. A drawing using varying shades of

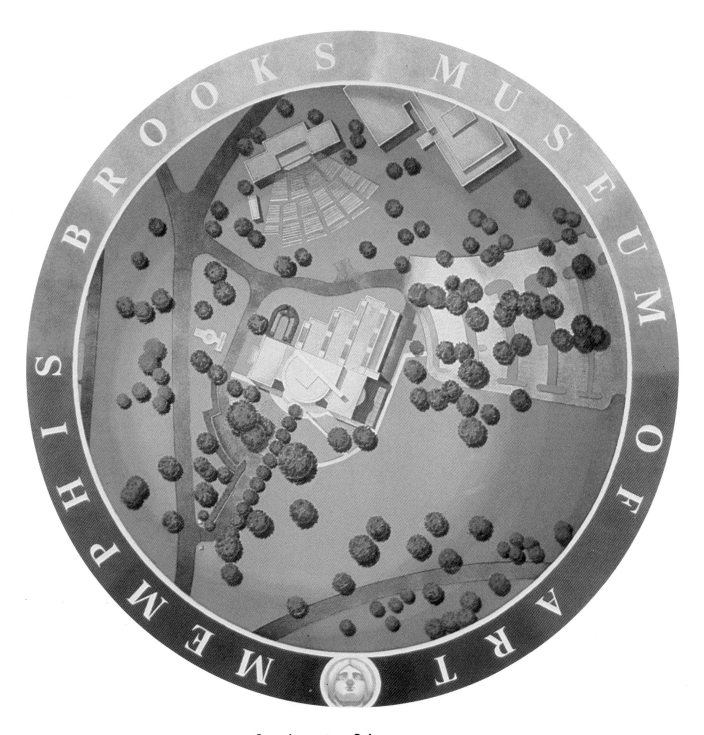

Complementary Colors

PROJECT:
Memphis Brooks Museum of Art
Memphis, Tennessee
ARCHITECT:
Skidmore, Owings & Merrill

A color composition can be based on varying shades of complementary colors. Here, the reddish border complements the green grass and trees. Similarly, shadows falling on the grass, rather than being gray, are Prussian blue tinged with cadmium red.

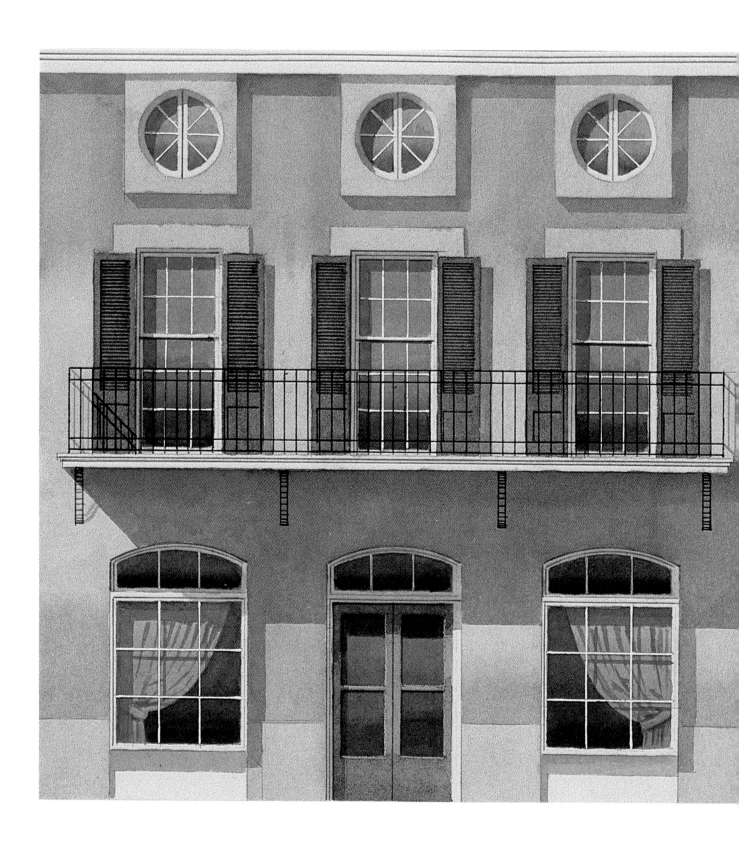

Shadows

Often the shadows in a drawing, rather than the objects themselves, are more important in making a drawing come alive. They help to define the form and details of a building. In this drawing, the shutters, the curtains, and even the balcony and railing are all defined by their shadows.

Shadows also influence the color composition. Here, purple is used to render the shadows on the pink stucco wall, and Prussian blue is used for the shadows on the windows. Although most people envision shadows in varying shades of gray, an excessive use of gray tends to deaden a color drawing.

You need not always use flat washes to create shadows. In this example, a graded wash of burnt sienna is painted over the purple just under the balcony in order to darken it. (Burnt sienna was used because browns complement purples nicely.) A large shadow will always be darkest at the edge nearest to the light source.

complementary colors can be quite striking (see page 23)

Like a mosaic, a drawing is made up of many different, discrete areas of color, and when these colors work together correctly, the resulting color composition is one that is pleasing to the viewer. When planning a color composition or deciding which colors to use, remember that the effect of one color is greatly influenced by the others in the composition. Thus, although one color may be beautiful by itself, when placed in the overall drawing, surrounded by other colors, it may not be right at all.

In our own work, the thing that most influences our choice of colors is the fact that we do not use line to define form; we use color and contrast. Johannes Itten states in his book, *The Art of Color* (1973), that "color areas should take their form, extent, and outline from chroma and intensity and not be predetermined by delineation. The correct sizes of color areas are not to be laid out by means of outline since the proportions are governed by chromatic forces evolving out of hue, saturation, brilliance and contrast effects."

Often, when one is just beginning to use watercolors, it is difficult to know which of the many tubes of paint to buy. Through experience, we have determined a palette of specific pigments that allows us to mix the colors we need. Although we still need to expand upon that palette occasionally for specific drawings, it keeps us from becoming overloaded with choices and gives us a very workable selection of colors. Probably the three pigments we use most are Grumbacher's alizarin crimson, ultramarine blue, and burnt umber. As mentioned before, we avoid using any gray or black pigments. When we need a neutral gray, or a warm or cool gray, we mix burnt umber and ultramarine. This is a very old method used to create gray, and the result is a gray with more subtlety and chromatic variety than a gray produced by the dilution of black. However, we do have one word of caution: even this more benign mixture of ultramarine and burnt umber must be used sparingly in a drawing. Many

architects choose building materials that are in the gray range, and it can be quite tempting to an artist to render an entire building in varying shades of gray. We have found that, whenever possible, it is better to use pure colors than "grayed" ones to illustrate those materials. Otherwise, the drawing has a tendency to look gloomy and lifeless, which may disappoint the architect and/or client. Use gray cautiously, and look for ways to mix gray. For example, Prussian blue and alizarin crimson make a lovely cool gray that may be used in many cases instead of ultramarine and burnt umber.

In architectural drawings, shadows are an important element. Not only do they help to define the form of a building, but they also make an entire drawing appear more real. At the same time, the color one uses to paint shadows influences the color composition of the drawing. We have found that a colored shadow rather than a grayed one not only possesses more depth, but also enhances the overall color composition. For example, the shadow of a pink stucco wall may be a very intense purple (see page 24). You should experiment with different colors. If you are stumped, the colorful shadows of Winslow Homer or Edward Hopper can be useful guidelines.

Another way of enriching and controlling the color composition of a drawing is to combine colors or grade them, one on top of another. Rather than painting a blue sky and grading it darker by using more of the same color, we tend to use a different blue, or even a violet, to darken and enrich it.

It is important to remember that the placement of colors is influential in a composition. There is usually going to be a balance of color distribution in the overall drawing. Thus it is not only the choice of color, but also the placement of that color, that affects the completed drawing. The step-by-step examples in this book are a more specific portrayal of how certain colors can be used in rendering certain materials, and how these smaller pieces go together to make up the whole drawing.

MONOCHROMATIC DRAWINGS

Every so often, a monochromatic drawing is more appropriate than a full-color one, either because of the time schedule or because the images or type of illustration lend themselves to this type of drawing. Monochromatic drawings are easier and faster to do than full-color illustrations and can often be quite dramatic. Many beautiful ink-wash drawings were done during the Beaux-Arts period and serve as good examples. (Ink as well as watercolor can be used to create monochromatic drawings.) As color composition is not an issue with monochromatic drawings, the crucial concern is the contrast of lights and darks and the way they interact to define form. The success of black and white drawing, like black and white photography, depends heavily upon the overall composition and the balance of light to dark areas. Since there is not the distraction of color, the composition must be very strong and clear.

In watercolor, there are several grays that can be used directly out of the tube, such as Davy's gray and Payne's gray. Payne's gray has a deep, rich blue cast to it and grades fairly easily. Davy's gray, however, is somewhat difficult to grade. Its strong greenish cast makes it unsuitable for an entire drawing.

Beyond these two pigments, gray can be made by combining other pigments. Traditionally, gray has been made by mixing burnt umber and ultramarine blue. As ultramarine is sedimentatious, it is sometimes difficult to achieve a perfectly graded wash with this combination. However, with some practice you can get an acceptably even wash. An advantage to this technique is that the combination of these two pigments allows you to add either more blue or more burnt umber to control the warmth or coolness of the wash. Many watercolorists use this combination to create shade and shadow, laying ultramarine and burnt umber washes down as a gray underpainting, before applying color on top. This was a common practice in eighteenth-century watercolor drawing. However, such an approach in a full-color drawing leads to results that look chromatically dull, if not downright grimy. (One of our clients quite correctly described a drawing we had done in this manner as "gloomy.")

If you wish to create grayed areas in a color drawing, a better technique would be to use a combination of Prussian blue and alizarin crimson. This combination, which we often refer to as "Prussian purple" to distinguish it from the more brilliant purple made with ultramarine blue, complements most colors quite nicely. However, although this mixture works well when a gray is needed in a full-color drawing, the strong purplish hue may be too overpowering in a monochromatic drawing.

Two other medium options for monochromatic drawings are lampblack watercolor or Higgins black nonwaterproof drawing ink. The ink can be applied using the same techniques and brushes as used with watercolor. It produces a slightly warmer gray than the lampblack; however, the lampblack is much easier to grade. Both media can result in striking drawings, incorporating the full range of values from the blackest ink to the white of the paper.

Ranges of Gray

These six bands illustrate the range of gray values that can be achieved with watercolor or drawing ink.

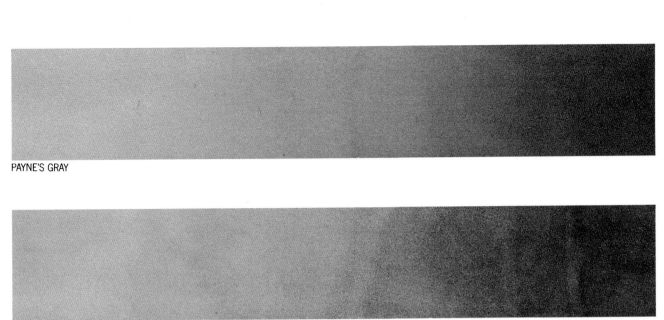

PAYNE'S GRAY

DAVY'S GRAY

BURNT UMBER AND ULTRAMARINE

PRUSSIAN BLUE AND ALIZARIN CRIMSON

LAMPBLACK

HIGGINS NONWATERPROOF DRAWING INK

Here is an example of a monochromatic drawing in which only Grumbacher's lampblack watercolor is used.

1. First, the windows and stone sills are masked with drafting tape and a smooth wash is put down to indicate a light-value brick. Next, a second coat is put down for a medium-value brick.

2. Next, the windows are painted, each one graded darker at the top and lighter at the bottom. This is done in three separate coats. The first wash is the lightest and is taken about three-fourths of the way down before it is graded. A second, darker wash is taken halfway down, and a very dark wash is taken one-fourth of the way down. The lampblack dries quite a bit lighter than it appears when wet, so a bit of experimentation may be needed. Mullions are then added using a ruling pen with a very dark wash of lampblack.

3. Shadows and details are then added. The brick patterns are painted and the entry is completed.

1

2

3

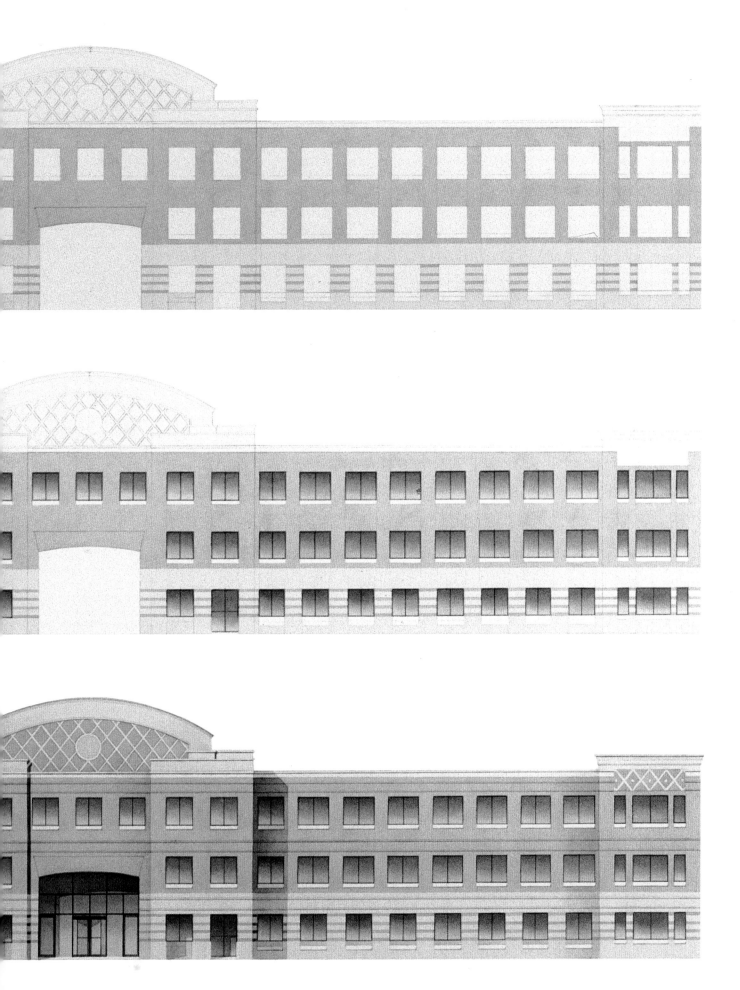

PROJECT:
Memphis Brooks Museum of Art
Memphis, Tennessee
ARCHITECT:
Skidmore, Owings & Merrill

These illustrations were done with Higgins black nonwaterproof drawing ink. Although the final results are quite nice, the ink is difficult to use, particularly for grading large areas. For this reason the night sky was done with an airbrush. If you do not have an airbrush, you may substitute lampblack watercolor, which is easier to work with than ink.

Because there are no colors in these drawings, it is the contrast of values that allows one to differentiate between planes. Dark shadows are extremely important in "explaining" the building shown in the daytime elevation. For a drawing such as the night view, an artificial light source must be established—usually located at the base of the building—causing shadows to be cast upward.

Due to the black and white nature of the medium, components such as grass and trees must take on an abstract quality. Because color cannot be used to define the green of the grass, graded washes must be used to convey the idea of a lush, soft carpet. In these drawings, the ink has a beautiful, old quality to it and the results are quite elegant.

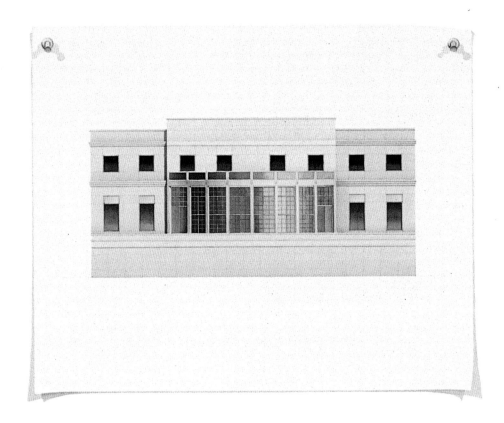

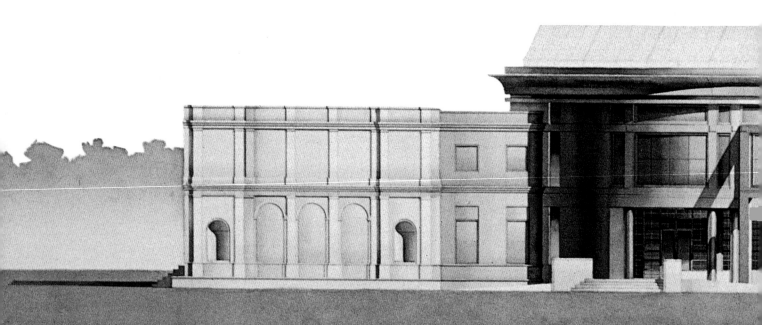

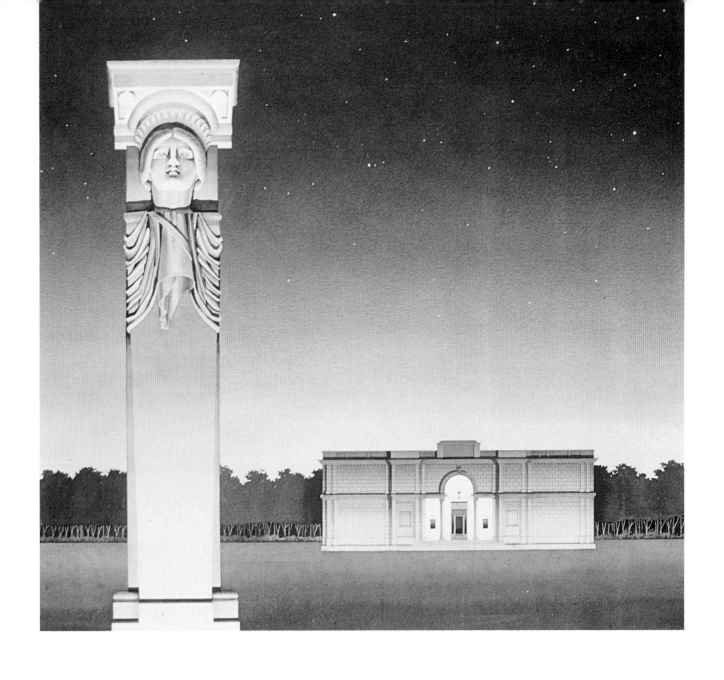

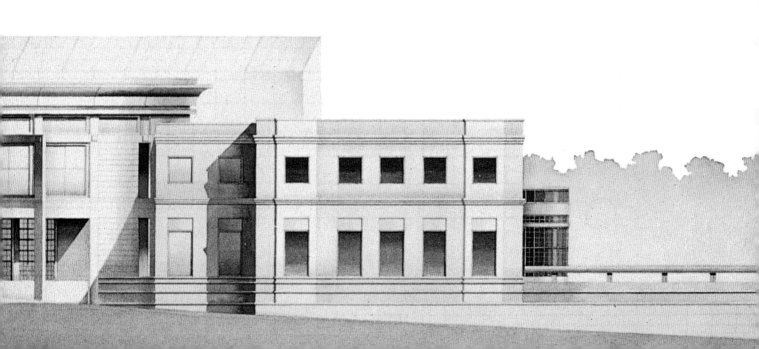

SUPPLIES
AND
TECHNIQUES

3. SUPPLIES

THE AMOUNTS and expense of material required to work in watercolor are relatively modest compared to those of other media. Although relatively few materials are required, it usually pays to buy the best. The most important tools and supplies are paper, brushes, and paints, and these usually will require the largest cash outlays. If you are an architect or designer, you will probably already have most of the additional supplies required to work in watercolor.

BRUSHES

Anyone who wants to do high-quality drawings in watercolor should invest in high-quality brushes. Unfortunately, these brushes are expensive, but you probably will need no more than four or five brushes. The quality of the brush is largely determined by the quality of the bristles. The brushes with the best bristles are labeled "finest red sable," "sable," or "kolinsky." A good-quality brush, when dipped in water, will form a sharp point at the end of its bristles. When touched to paper, it will discharge paint in a thin line or wide stream, depending upon the hand pressure exerted. A poor-quality or worn-out brush will not form a point when wet, and it will be difficult to control the flow of paint with one.

The size of a brush is identified by a number, the smallest brushes having the smallest numbers. At our studio we use brushes having sizes 00, 0, 1, 2, 4, 6, 10, and 26. Brushes sized 00 and 0 are used for fine line and detail work. Brushes sized 10 and 26 are used for large washes. The in-between sized brushes we use for everything else, and we use them quite frequently. If you are a beginning watercolorist, you can get by comfortably with about half of these brushes. Sizes 00, 1, 4, 6, and 26 would make a good beginner's collection.

The smaller the brush, the less expensive it is. Almost anyone can afford a size 0 red sable brush, but a size 26 red sable may require you to apply for a bank loan. Fortunately, in the larger sizes, a medium-priced brush is quite adequate. We have been using a comparatively inexpensive, size 26 Robert Simmons brush for years, with total satisfaction. A moderately priced alternative to sable brushes are those whose bristles are part sable and part synthetic. They do not seem to hold paint as well as all-sable brushes, but they are very good for most applications. The sturdiness of the bristles and the low price also make these brushes very suitable for such abusive uses as applying liquid frisket.

Care of watercolor brushes is a simple matter but does require a certain degree of diligence. Brushes should be stored flat in boxes designed for this purpose or stored standing up in jars, bristles pointing upward. Between washes, brushes should be swished in clean water to remove the remaining pigment. You should never allow brushes to dry without cleaning them, as pigment will cause the bristles to harden. If this does happen, the dried watercolor usually can be removed by dipping the bristles in warm water and wiping them clean with a soft paper towel. Finally, brushes should never be allowed to stand in a glass of water with bristles submerged and pointing down. To do this even for a few minutes can permanently distort the shape of a brush and render it useless.

Professional watercolorists can use a brush for about a year before it has to be replaced. The brushes of a non-professional artist, if properly cared

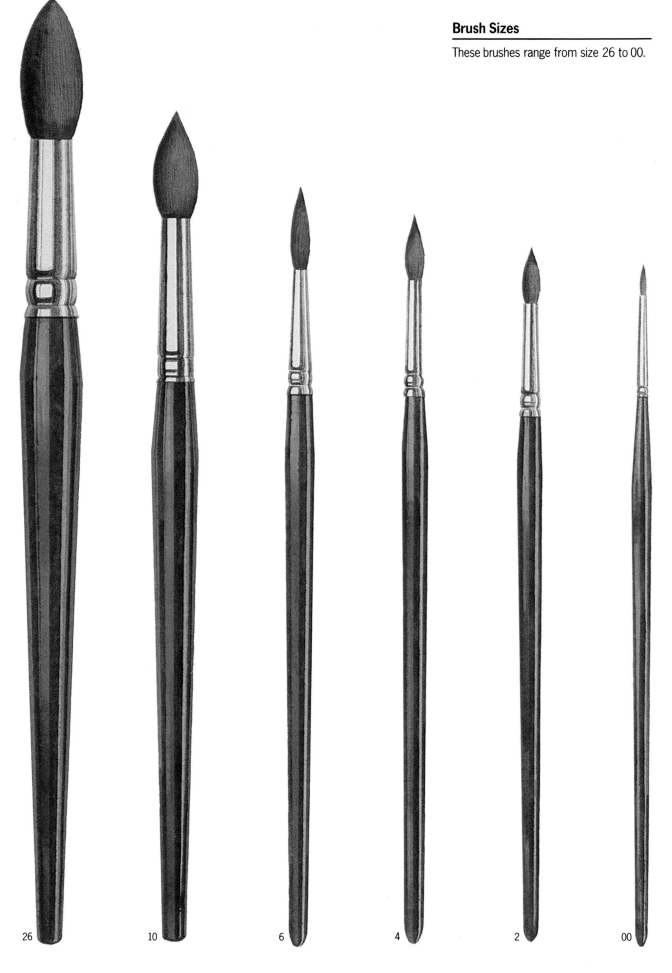

Brush Sizes

These brushes range from size 26 to 00.

26　　10　　6　　4　　2　　00

for, should have a considerably longer life span. Even after a brush has lost its resilience, it can still be used for lifting out color, applying frisket, or doing color sketches. Worn-out brushes can also be handed down to one's artistically inclined children, as even these brushes will be of superior quality to the cheap varieties found in toy stores.

PAPER

Watercolor paper is categorized according to finish and weight. Three finishes are available: rough, cold press (or medium), and hot press (or smooth). The rough finish is as the name implies: its surface is highly textured. Rough finish paper is often favored by artists who work in a loose, quick, sketchy style. The results in terms of color and texture can be brilliant; however, the paper is not particularly well suited to highly detailed or precise drawing techniques.

At the other end of the spectrum is the hot press, or smooth, paper. The slick and very uniform surface takes ink well but tends to resist heavy washes. As a result, colors on such a paper are usually light or muted. For these reasons, this paper is well suited for doing ink line drawings with light watercolor washes laid on top.

In between these two extremes is the cold press, or medium finish, paper. It is highly versatile in that it will take both line work and heavy washes well, enabling it to be used for either precise or sketch drawings. You can manipulate the surface by lightly lifting or scrubbing out work, without seriously compromising the integrity of the finish. All of the drawings that appear in this book were executed on cold press paper.

When buying sheets of watercolor paper, you must select the weight you want. The weight is really an indication of the thickness of the paper as it indicates the number of pounds one ream of paper weighs. The higher the weight, the thicker the paper. Typical designations might be 70 lbs., 140 lbs., or 250 lbs. In choosing a weight, it is helpful to feel the thickness of the paper, to make sure you know what you are getting. In general, a heavier weight paper will be more expensive to buy than a lighter weight one.

A single sheet of watercolor paper will be very flat, but as with any paper, it will buckle and warp when it is wet. This is particularly true of the lighter weight papers. This hazard can be avoided by "stretching" the paper, or by using a very heavy paper. The heaviest papers will still warp, but to a far lesser extent than the lighter papers.

A good quality paper will always be termed "100% rag." The term was adopted at a time when watercolor papers were made from linen rags. It is an indication that the paper is acid-free and will not yellow or disintegrate over time the way that cheaper papers such as newsprint will.

Watercolor paper can be purchased as sheets, rolls, boards, or blocks. A watercolor board is a sheet of watercolor paper laminated to a stiff backing such as cardboard. Boards are available in the usual textures and do not require stretching. Although their paper surface may be acid-free, their backing may not. Boards are very convenient, but, if you are interested in longevity, you should make sure that the backing is also acid-free, or else use sheets.

A watercolor block is a set of precut sheets bound together on the sides with an adhesive. Watercolor is painted on the top sheet of the block, and, when the drawing is done, the sheet is simply cut loose from the block. As blocks are usually a compact size and the sheets do not require stretching, they are ideal for quick *in situ* sketches.

There are numerous well-known brands of watercolor paper from which to choose, such as Arches, Fabriano, Whatman, Bockingford, and Strathmore. In our work we favor Arches' cold press watercolor paper in either the 140 lb. or 300 lb. weight. It is a versatile, high-quality paper that yields good results. This is not to say that you should not experiment to find the paper that best suits your needs. Each has unique strengths and weaknesses. Purchasing a number of small sheets of different brands and doing test washes on them should help you to determine which one is right for you.

PAINTS

Commercially prepared watercolors traditionally have been sold as dried cakes. Although watercolors can still be purchased this way, most watercolorists buy their colors in tubes. The colors are squeezed out onto palettes, as with oils or acrylic paints, and mixed with water. As the colors dry on the palettes, they can be reactivated by adding more water, as is done with cakes.

Most watercolor tubes are small. Typically, sizes range from eight to seventeen fluid ounces. It is common for a manufacturer to produce several lines of watercolors, of varying prices. The cheapest are often marketed to students and other beginners. Grumbacher, for example, markets its cheaper "Academy" line as well as the pricier "Finest Artists' Water Color." Although you can achieve perfectly respectable results with the cheaper lines, it behooves the "serious" beginner to buy top-of-the-line colors for better results in terms of brilliance and permanence.

To the uninitiated, the price of a small tube of watercolor might seem high. It helps to remember that a little goes a long way. You should buy the smallest tubes available. Chances are that most tubes will last you a very long time—at least several months.

While there are many different colors to choose from, you only need a fraction of those available. Although we have a collection of about twenty-three colors (see facing page), routinely we do not use more than about fifteen. In a single drawing, we seldom use more than five to ten.

Colors will vary somewhat from one manufacturer to another. Although two or more colors may share the same name, a color produced by one manufacturer may look quite different from that produced by another. For example, Grumbacher's burnt umber is darker and browner than Winsor & Newton's. We like to use Winsor & Newton's burnt umber for light washes when a creamy beige is desired, and Grumbacher's for washes when medium to dark values are desired. For the beginner this difference is relatively unimportant. It is more important that he or she choose

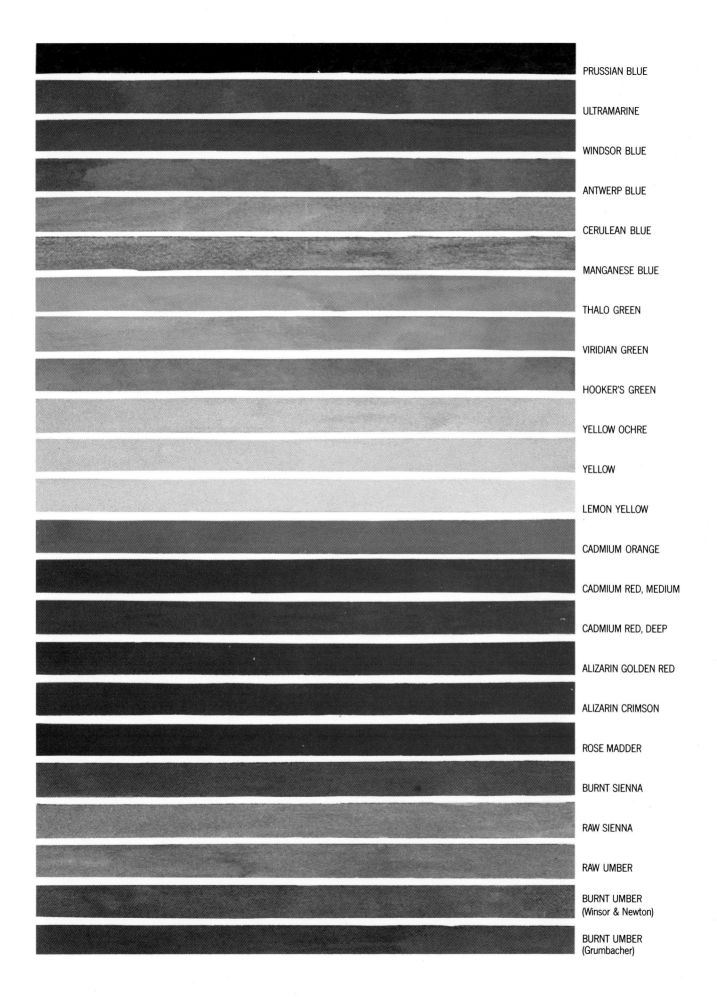

PRUSSIAN BLUE

ULTRAMARINE

WINDSOR BLUE

ANTWERP BLUE

CERULEAN BLUE

MANGANESE BLUE

THALO GREEN

VIRIDIAN GREEN

HOOKER'S GREEN

YELLOW OCHRE

YELLOW

LEMON YELLOW

CADMIUM ORANGE

CADMIUM RED, MEDIUM

CADMIUM RED, DEEP

ALIZARIN GOLDEN RED

ALIZARIN CRIMSON

ROSE MADDER

BURNT SIENNA

RAW SIENNA

RAW UMBER

BURNT UMBER
(Winsor & Newton)

BURNT UMBER
(Grumbacher)

a good line of watercolors. As you gain experience and begin to want to experiment, you can try different brands.

Colors also vary from one another in the visual textures they create on paper. Most colors dissolve easily in water and, when properly applied, produce even, uniform washes. The pigments of most colors tend to soak into the paper as a wood stain does in wood. Others, however, never totally dissolve, and tend to sit on top of the paper, creating a slightly opaque color. This is especially true of the cadmium colors, which have a somewhat chalky appearance on paper. Other colors, such as ultramarine, cerulean blue, and manganese blue, are rather sedimentatious and their pigments, when mixed with water, tend to settle to the bottom of the liquid. Washes done with these colors are often streaked and speckled. These are qualities many watercolorists admire, but they are not always appropriate (for example, if you are trying to depict in your drawing a perfectly clear day).

The sedimentatiousness of certain colors can be mitigated somewhat by mixing them with other colors. Ultramarine, for example, can be mixed with alizarin crimson to produce a perfectly smooth purple, or with burnt umber to produce a smooth gray. Washes containing ultramarine, however, must be stirred frequently with the brush to prevent the pigment from settling.

The following section lists alphabetically the colors we paint with most frequently, as well as descriptions of their particular characteristics and uses.

Alizarin crimson: An indispensable color. The most versatile red. Mixes with ultramarine to form purple. Mixes with Prussian blue to form an intriguing gray. Can be darkened with Prussian blue or Hooker's green. Light washes of alizarin crimson are pink.

Antwerp blue: Approximates manganese blue, but is much easier to control. Indispensable for sky washes.

Burnt umber: An indispensable color. The most frequently used brown. Mixes with ultramarine to form gray.

Burnt sienna: A very orangy brown. Used to render brick and terra-cotta. Used as an accent in rendering polished bronze.

Cadmium orange: A very bright orange. Like all cadmium colors, slightly chalky and opaque. Not suitable for rendering most architectural materials, but may be used for people, cars, flowers, and so forth.

Cerulean blue: A very bright and beautiful blue. Used to render the deep blue sea. Extremely sedimentatious. Must be mixed with Chinese white to create smooth washes.

Chinese white: A totally opaque watercolor. Used more as an admixture than a color. Also used for white highlights. Mixes with other colors to produce gouache.

Cobalt blue: Can be used interchangeably with ultramarine.

Hooker's green: Used for grass and trees. Can be darkened with Prussian blue or alizarin crimson.

Manganese blue: A very beautiful blue with a mind of its own. (On paper, the pigment seems to move around in unpredictable ways before it dries.) Similar to Antwerp blue, but brighter. Extremely sedimentatious. Must be mixed with Chinese white to produce smooth washes.

Prussian blue: An indispensable color. One of the darkest blues. Used for sky washes, shadows on grass, and glass. Can be mixed with alizarin crimson to form colors ranging from ultramarine to purplish gray. Mixes with raw umber to form a subdued green.

Raw sienna: A yellowish brown. Used as an accent in rendering polished bronze. Usually used in light washes.

Raw umber: A lighter and slightly greener version of burnt umber. Mixes with Prussian blue to form a subdued green. Mixes with alizarin crimson to form salmon pink. Mixes with thalo green to render aged copper.

Thalo green: A bright blue-green. The color of the Statue of Liberty and green glass. Mixes with raw umber to render aged copper.

Ultramarine: An indispensable color. The most frequently used blue. Mixes with burnt umber to form gray. Mixes with alizarin crimson to form purple. Can be darkened with Prussian blue. Used to render shadows. Sedimentatious and slightly opaque. Can be used for large light washes if frequently stirred. Can be used for dark washes if area to be painted is small. For deep blue washes over a large area, must be mixed with Chinese white.

Viridian green: Can be used interchangeably with thalo green.

Yellow ochre: The most versatile yellow. Used as the principal color when rendering polished bronze.

ADDITIONAL SUPPLIES

Paper, paints, and brushes represent the major cash outlays for watercolorists. In addition to these supplies, there are several others that will be needed. With the exception of ruling pens, these will be very modest in price; most are either household items or common drafting tools. The following is a list of these supplies, with a brief description of each item:

Drafting pencils: Use "H" or "HB" pencils for drawing on watercolor paper. Lines drawn with pencils any harder than these are difficult to erase.

Colored pencils: Use in place of ruling pens for drawing thin straight lines. A white pencil is particularly useful for drawing light lines on a dark watercolor background.

Erasers: Use a soft vinyl eraser (or preferably a kneadable eraser) for erasing pencil lines from watercolor paper.

Drafting tape or masking tape: Use masking over unpainted paper where a hard watercolor edge is desired.

Liquid frisket: Use for masking over unpainted paper when areas to be masked are small and irregularly shaped. Available with or without an added pigment. Those with pigments are easier to see on white paper, but may leave stains on the paper. Liquid frisket is applied with a brush and

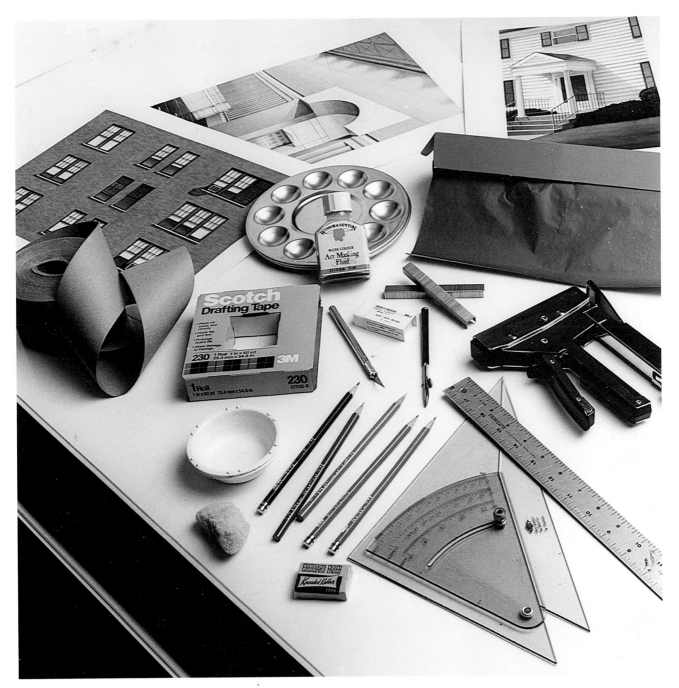

dries to become a rubbery film that can be removed with gentle rubbing.

Transfer paper: A paper with a graphite film on one side used for transferring line drawings to watercolor paper. It works on the same principle as typewriter carbon paper.

Gummed paper tape: Use with a heavy-duty stapler to stretch watercolor paper.

Heavy-duty stapler: Use to hold wet watercolor paper to a board while paper is being stretched.

X-Acto knife: Use for cutting paper and correcting mistakes.

Ruling pen: An all but archaic drafting tool that has been largely replaced by modern technical pens. It is without equal, however, for drawing straight lines in watercolor. Although an inexpensive ruling pen is often included in many compass sets, it pays to invest in a top-of-the-line pen. Here is an example where cost is in direct proportion to quality.

Palettes: Trays used for mixing colors with water and with each other. Although heavy, expensive ceramic ones are available, plastic or aluminum palettes work just as well and are extremely reasonable.

Sea sponges: Sometimes called "elephant ear sponges," and not to be confused with the synthetic household variety. Use for lifting or scrubbing out watercolor and for dabbing color onto paper to depict clouds and trees.

4. TECHNIQUES

ONTRARY TO popular opinion, it is not necessary to learn a lot of painting "tricks" to achieve proficiency in watercolor. A certain degree of patience is required, however, to learn the few basic techniques you must master to work successfully in the medium. Practice the steps outlined in this chapter until you feel comfortable, repeating them before you try a finished drawing.

STRETCHING PAPER

Once the task of choosing a specific type of watercolor paper has been completed, sheets must be "stretched" to keep them from buckling later when wet. A sheet that is stretched before it is used will always dry flat after washes are applied. Unless you are using a very heavy or oversized sheet, it is best to stretch the paper before you begin.

Several supplies are essential to the stretching process: 1) a roll of paper tape about two inches wide, 2) a heavy-duty staple gun and ⅜" heavy-duty .050 wire staples, 3) paper towels, and 4) a wooden board several inches longer and wider than the sheet to be stretched. A board with metal edges is best as the metal keeps the wood from warping. These boards are available in many art supply stores, although they are usually marketed as "drawing boards." Once you have these supplies, the only other items you will need are a large flat table on which to work and a source of running water. If the sheet you are stretching is small, a sink (utility, if possible) will work fine. However, for larger sheets, a bathtub will work best.

Because you need to work fairly quickly when stretching a sheet of watercolor paper, it is important to have your materials prepared before you begin. Have the board set flat on the work surface and have pieces of paper tape cut to size. Next, you can either soak the paper in an impeccably clean bathtub for several minutes, or you can hold it under running water until it becomes totally saturated. With the latter method, you will need to let the water run on each side for several minutes, repeating the process four or five times, until there is no doubt that the paper is soaked. Often at this time you will see some irregularities in the density of the paper. (This is due to the fact that sizing gets rinsed out as the paper is soaked. Once the sheet is dry, however, these irregularities will have disappeared.)

At this point, any excess water is drained off and the sheet is carefully placed flat on the wooden board. The sheet is then taped down with the paper tape. There is no need to pull on the paper before taping it, as long as it is laid flat. If it is a big sheet (over 20″ × 30″), it must be stapled to the board with a heavy-duty stapler. The sheet is then left to dry. The board may be propped up or left flat while the paper dries and it is usually six to eight hours until it is ready for use. During the drying phase, the paper will become quite buckled and you probably will be convinced that you have done something wrong. However, if the sheet is left alone, it will, amazingly enough, dry perfectly flat.

After it is dry, the paper is ready to be used. It may buckle a bit when large washes are put on, but it will always dry flat. The whole process of stretching is fairly simple, and definitely worth the extra time and effort.

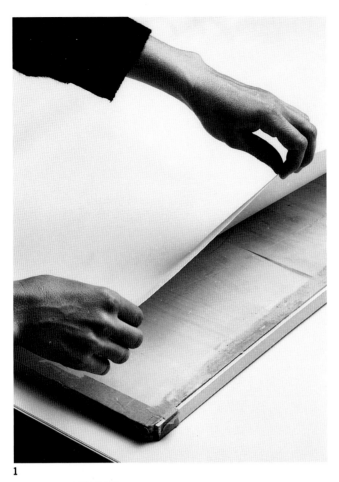

1

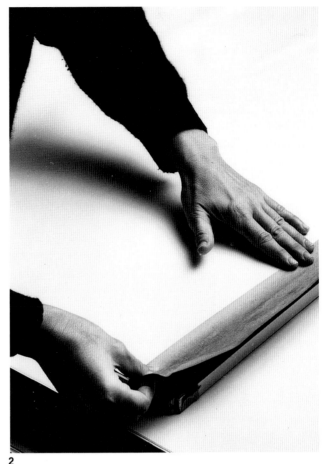

2

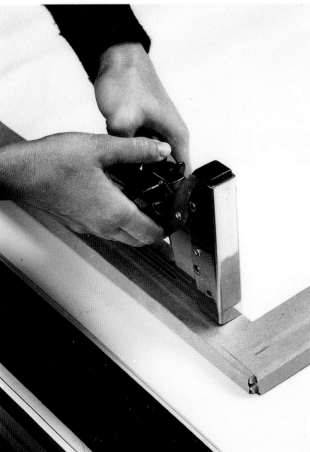

3

Stretching Techniques

1. Watercolor paper must be stretched on a wooden board that is at least several inches longer and wider than the paper itself. A portable wooden drawing board with metal sides is ideal. Soak the paper in clear water for several minutes until it is totally saturated, and position it on the board.

2. Tape the paper to the board with moistened strips of paper mailing tape two or three inches in width. The tape should overlap the edges of the paper by one inch.

3. If you are stretching a big sheet (20″ × 30″ or larger), it must be stapled to the board with a heavy-duty stapler. Staple through the areas where tape overlaps the paper. The staples should be spaced about six inches apart. Any staples that protrude can be hammered down until they are flush with the surface of the paper.

TRANSFERRING A LINE DRAWING TO PAPER

After the paper has been stretched and is ready for use, the line drawing to be painted must be transferred to the watercolor paper. If the paper has not been stretched, a light table may be used in tracing the drawing onto the paper. However, beyond the fact that a light table is very expensive, this method will not work if the paper has been stretched onto a board. There is another inexpensive and simple method of transferring—it involves using transfer paper, a type of carbon paper. A blueprint of the line drawing is positioned on the water-color sheet and taped in place. Then, a sheet of transfer paper is slipped between the blueline and the water-color paper, and, with an H or 2H pencil, the blueline is traced. In this way, every line of the drawing is transferred onto the watercolor pa-per. Because different brands of trans-fer paper yield slightly different re-sults, it is best to experiment with various types. (We prefer to use Saral Transfer Paper, which is available in most art supply stores and can be bought by the roll.) After the water-color painting has been completed, any transfer line still visible through the paint can be erased with a soft vinyl eraser, such as the one made by KOH-I-NOOR. In this way the orig-inal line work totally disappears, leav-ing only the watercolor drawing.

Transferring the Drawing

To transfer a line drawing to watercolor paper, a blueline print of the drawing is first positioned on the paper and taped in place. Next, a sheet of transfer paper is slipped between the blueline and the watercolor paper. Lines on the blueline print are traced with an H or 2H pencil. After every line has been traced, the blueline and the transfer paper are peeled away, revealing the transferred drawing.

PUTTING DOWN SMOOTH AND GRADED WASHES

Depending on the pigment, the size of the area to be colored, and the desired intensity of color, a smooth watercolor wash can be extremely easy, or extremely difficult, to put down. Obviously, it is best to start out with simple washes and progress to more difficult ones. The lighter the color, the easier it will be to put down a smooth wash. Depending on the size of the area to be covered and the configuration of that area, it may be helpful to mask the edges with drafting tape. This will allow you to concentrate on putting the paint down smoothly without worry over keeping the edges crisp. However, the tape will work only on areas that have not yet been painted. If tape is put over an area that has a wash on it, the new wash that is put down will seep underneath the tape. For this reason, it is important to plan ahead.

In order to execute a smooth wash, you must work calmly and quickly. Mix up enough wash so that you do not have to stop later to mix more. If the wash is fairly dark, put down a wash of clear water first, in several coats. If the wash is a light one, this is not necessary. To put the wash down, load your brush with paint and work back and forth, painting continually as you move down the sheet. You must not work back into an area already painted and you must always work wet into wet. If the color you put down in a stroke dries before you execute the next stroke, there will be an "edge" instead of a perfectly smooth wash. Anything that touches a dried wash will leave a mark.

Once you have achieved smooth washes using one color, you may attempt graded washes. These are more difficult and will be learned from trial and error. A graded wash is one that is thinned with water as it is put down. In this way, it is darker and more intense at one border and lighter and more transparent at the other. Graded washes can be done with one color or with several, one color on top of another. This will take practice, but some beautifully rich and intense effects can be achieved this way.

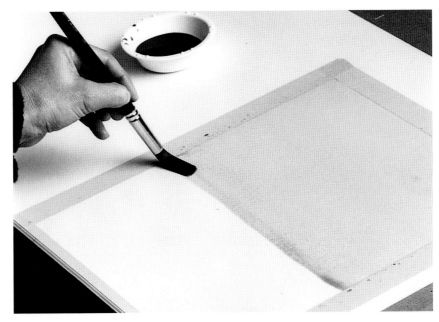

Smooth Washes

Before painting a large area, mix up enough watercolor wash (watercolor from the tube plus water) so that you do not have to stop later to mix more. If the wash is fairly dark, it helps to put down a clear coat of water first. Before proceeding, allow the paper to dry just enough so that there is no wet sheen on the surface, but so that the paper is still damp to the touch. To put color down, load your brush with the watercolor mixture and work back and forth in continuous horizontal strokes as you move down the paper.

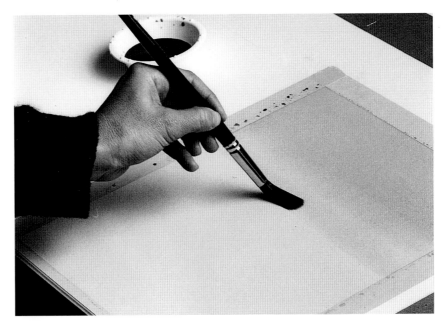

Graded Washes

A graded wash is one that is thinned with water as it is put down. After the smooth wash has dried, a second coat of the same color is applied to the top third of the paper. The bottom two-thirds is completed with a wash of clear water, using the same back-and-forth motion as before. This technique allows the colored wash to bleed into the clear wash. When it is dry, the painted area will be darker and more intense at the top, and lighter and more transparent at the bottom.

DRAWING STRAIGHT LINES

There are two basic ways to draw straight lines with watercolor: with a brush or with a ruling pen. Ruling pens are available in most art supply stores in a wide price range. For doing precision work, a good one is needed; be prepared to spend what you would on a good quality brush. After you have mixed the paint, you should fill the ruling pen and adjust it to the desired opening or line width. You use it as you would any other pen: hold it against a parallel bar or triangle and draw a straight line. The use of a ruling pen is unquestionably the easiest way to draw straight lines for watercolor. The only problem you may have is that occasionally the pen itself scratches the surface of the paper.

The other alternative is to use a brush. Drawing a straight line with a brush takes a bit more skill or practice but can be just as effective. With a brush, you should use a triangle, scale, or other straightedge as a guide. While holding the straightedge in one hand, rest the brush against it and paint the line. In this way, your hand is steadied and a straight line can be painted. With some practice this method works quite well, although, if possible, drawing with a ruling pen is the preferable technique.

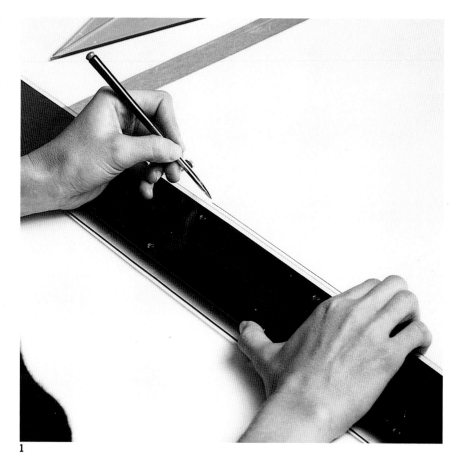
1

Straight Lines

1. The best tool for drawing straight lines in watercolor is a ruling pen. After you have mixed the paint, fill the ruling pen and adjust it to the desired opening or line width. It is used like a regular technical pen—you hold it against a parallel bar or triangle to draw a straight line.

2. The alternative to using a ruling pen is to use a brush. While lifting one edge of the parallel bar about an inch off the paper, rest the metal ferrule of the brush against the bar's edge and slide the brush along the edge to paint the line.

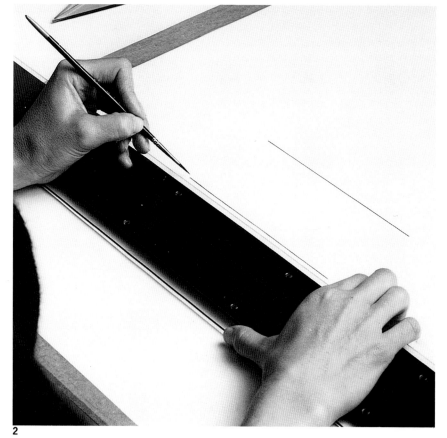
2

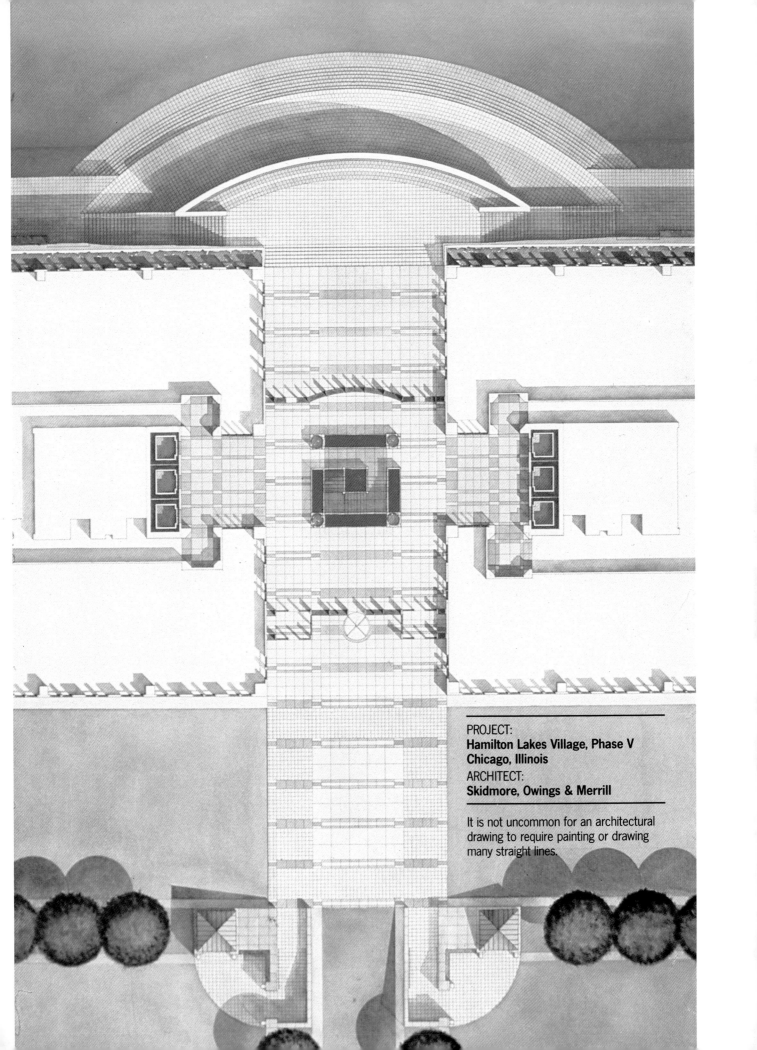

PROJECT:
**Hamilton Lakes Village, Phase V
Chicago, Illinois**
ARCHITECT:
Skidmore, Owings & Merrill

It is not uncommon for an architectural drawing to require painting or drawing many straight lines.

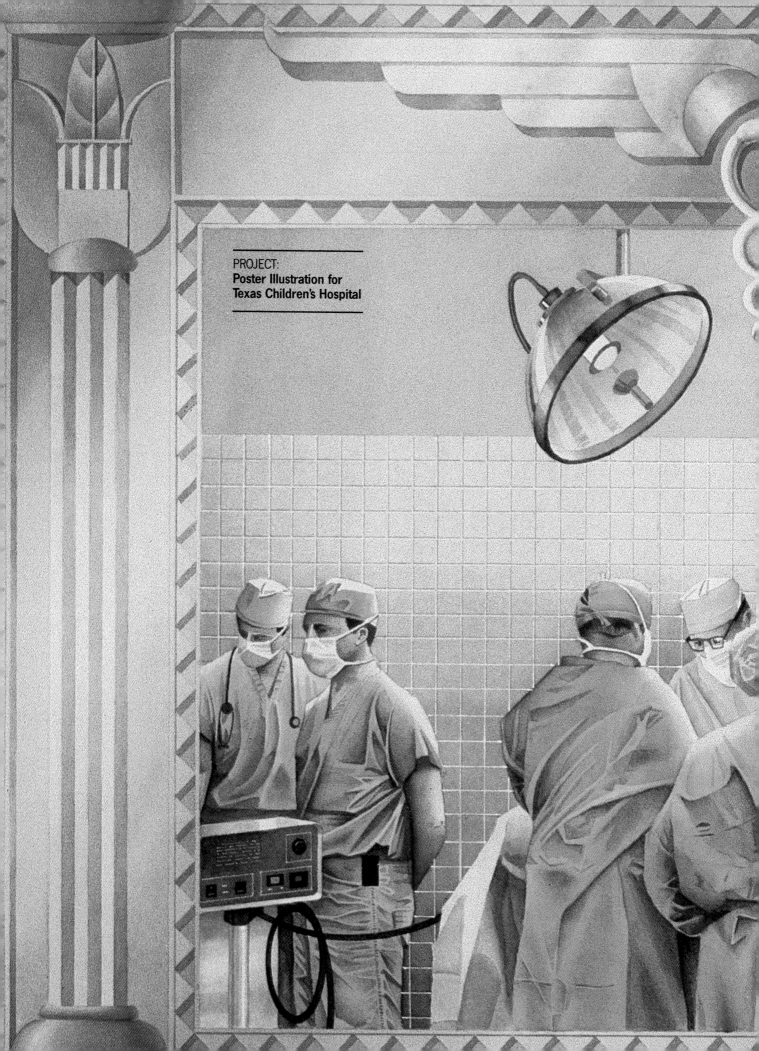

PROJECT:
**Poster Illustration for
Texas Children's Hospital**

ELEMENTS
AND
MATERIALS

5. ENVIRONMENTAL ELEMENTS

ARCHITECTURAL DRAWINGS portray a wide variety of building materials, as well as peripheral elements such as clouds, cars, trees, people, and furniture. Each of these materials and elements have certain visual characteristics that must be replicated in watercolor. Before learning how to create a whole drawing from start to finish, you should take a step-by-step look at those parts of the drawing that make up the whole.

CLOUDS/SKY

When discussing the color of the sky in architectural drawings, one is, in more cases than not, discussing the color blue. There are numerous blues which as hues would lend themselves well to this application, but which as paints present technical problems. Cerulean blue and manganese blue are two such examples. Both are luscious, aquamarinelike colors, either of which would make a beautiful sky color, but which, when applied in large washes, yield streaked and blotchy results. Similarly, it is virtually impossible to use ultramarine blue to create large, flat washes without streaking, due to its sedimentatious nature. There are watercolorists who have mastered techniques that allow them to use these colors when rendering skies, but these are not the smooth, seamless skies one sees on a clear autumn day.

If you are very attracted to these colors, however, and want to use them as sky washes, there are a few techniques that can help mitigate the effects described above. Chinese white can be added, which helps to homogenize the pigments and allows you to lay down relatively flat washes. Remember, however, that once Chinese white is added to watercolor, it technically becomes gouache, and gouache is difficult to grade unless you are using an air brush.

Ultramarine is less difficult to control than either manganese blue or cerulean blue, and can in some instances be used without the addition of Chinese white. The wash must be a light one, however, and the area to be painted must be relatively small. If you want to be particularly cautious, you can mix a large wash of ultramarine in a cup, allow it to stand until the heavier pigment sinks to the bottom, and decant the wash, which will leave the sediment in the bottom.

Fortunately, you can avoid all of these difficulties by using two colors that lend themselves beautifully to painting skies: Antwerp blue and Prussian blue. Antwerp blue is the brighter of the two and is somewhat akin to, although considerably more subdued than, cerulean blue or manganese blue. Because of its brilliance, it is more appropriate for light-value skies. In our own work, Prussian blue is the color of choice for sky washes. It can be used by itself or mixed with a small amount of alizarin crimson to create a blue with a strong resemblance to ultramarine. Purple can be painted over it to darken the color and tone down its brilliance. It is a very cozy blue, but it has two peculiarities. The first is that when mixed with Antwerp blue, it produces very streaked washes. The second is that

after a month or so, it darkens slightly and its brilliance dulls to produce a somewhat more somber color.

When applying dark or medium-value washes of any color, even Prussian blue, over a large area, you are likely to see imperfections in the paper. It is also difficult to apply a wash over a large area so that it grades smoothly from dark to light, with no striated bands of color. When these imperfections occur in a watercolor sky, they can be covered over somewhat with the addition of clouds.

Many excellent books have been written about watercolor landscapes, all of which deal with the topic of clouds. Because this book focuses primarily on architectural drawings in watercolor, clouds will not be discussed, except in the way in which our approach to painting clouds differs from that of other books. In watercolor painting, it is customary when painting a cloudy sky to let the white of the paper serve as the white areas of the clouds. This requires some forethought and planning, as well as careful manipulation of the basic sky color. In general, it is preferable to paint over the entire sky area with watercolor first, and then to add clouds by dabbing Chinese white on top of the color. As watercolor painting requires so much advance planning by the artist, we like this technique for the opportunity it offers to eliminate some of that planning. While this approach may be somewhat less "pure" than the traditional one, it does offer the possibility of dramatic results achieved with little effort. The following example illustrates how these effects are achieved.

1

Painting Clouds

1. Several graded washes of Prussian blue are laid down. Each one is allowed to dry before the next is applied. Between washes, the surface of the paper should look dry, and it should not have the sheen it has when it is wet. When you press your hand to the paper, it should feel slightly cool, indicating that it is still damp. The washes will be easier to grade, and, when dry, will look smoother if the paper has some dampness in it at this stage.

After about four such consecutive washes, the paper will be too wet to be painted on for awhile. It will need an hour or longer to dry before you should proceed with the next coat.

After the Prussian blue has been painted on, several graded washes of purple made with ultramarine and alizarin crimson are applied. After the paper dries completely, it will be ready for the addition of clouds.

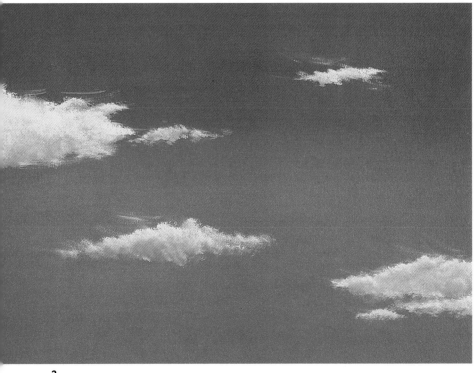

2

2 and 3. To add clouds, first dip a small sea sponge in water. Squeeze the sponge very tightly until all excess water drips out. The sponge should be damp but not wet. After lightly drawing the contours of the clouds onto the paper, dip the sponge into a mixture of Chinese white and water. You should add enough water to the white so that the consistency of the mixture falls somewhere between that of a very thick cream and mayonnaise. Now dab the white onto the paper in the shapes of clouds. This may require several applications, as Chinese white always looks much whiter wet than dry.

3

CARS

For many architectural drawings of exteriors of buildings in urban settings, an artist will be called upon to add a few cars. It will be a great help to him or her to be able to draw them accurately and resourcefully.

1

2

3

4

Drawing Cars

1. The gray and black values are painted in first with a mixture of burnt umber and ultramarine.

2. The entire body of the car is washed with a pink made of alizarin crimson and cadmium red. The darkest red values belonging to the back of the car are then painted in with the same colors that were used for the pink underpainting. This now establishes the darkest values and the lightest values for the entire car. The tire rim and its highlight are also painted in at this time

with a light coat of ultramarine.

3. The remainder of the car's body is then painted in with solid and graded washes of red. With the darkest values of the body painted in, it becomes obvious that the gray and black areas are too light, and they are darkened appropriately. The glass areas are washed with a light coat of ultramarine mixed with a tiny bit of burnt umber.

4. The dashboard and seats are added using a bluish gray. Notice that the contrast in the interior is muted in order

to give the impression that diffuse light reflects off the glass. Last, a diffuse shadow is painted in under the car using graded gray washes. Shadows are always done last. This particular shadow is very important in helping the car to "touch down." It is also important to note that metallic surfaces appear shiny here because of the strong contrast between light and dark values, and because of the reflections. Note especially the reflections of the side mirror in the car door and in the glass.

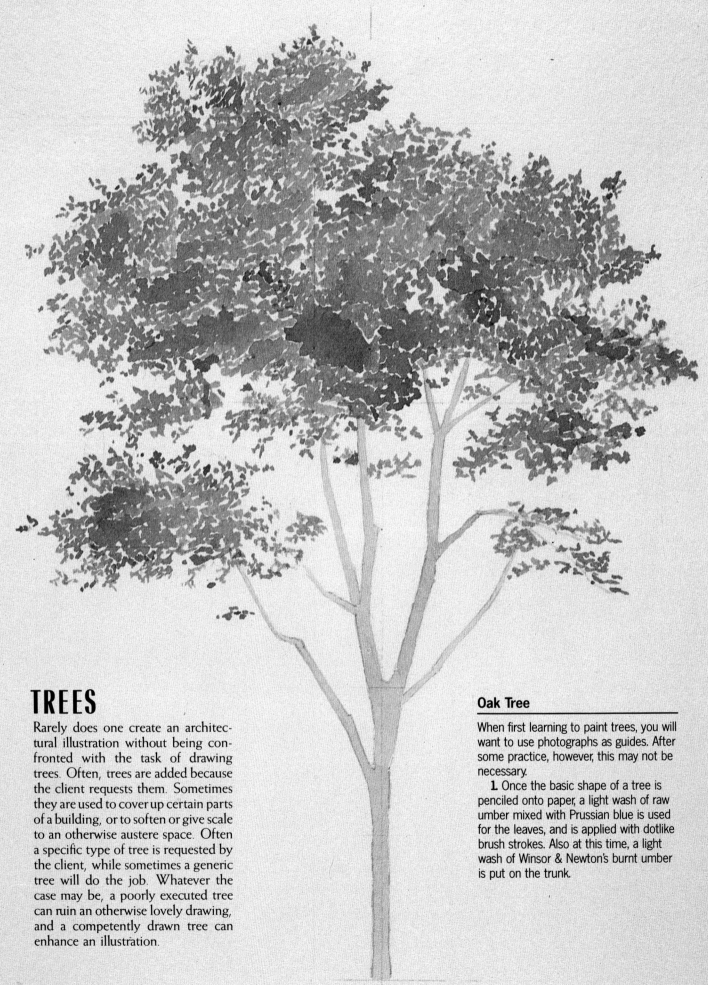

TREES

Rarely does one create an architectural illustration without being confronted with the task of drawing trees. Often, trees are added because the client requests them. Sometimes they are used to cover up certain parts of a building, or to soften or give scale to an otherwise austere space. Often a specific type of tree is requested by the client, while sometimes a generic tree will do the job. Whatever the case may be, a poorly executed tree can ruin an otherwise lovely drawing, and a competently drawn tree can enhance an illustration.

Oak Tree

When first learning to paint trees, you will want to use photographs as guides. After some practice, however, this may not be necessary.

1. Once the basic shape of a tree is penciled onto paper, a light wash of raw umber mixed with Prussian blue is used for the leaves, and is applied with dotlike brush strokes. Also at this time, a light wash of Winsor & Newton's burnt umber is put on the trunk.

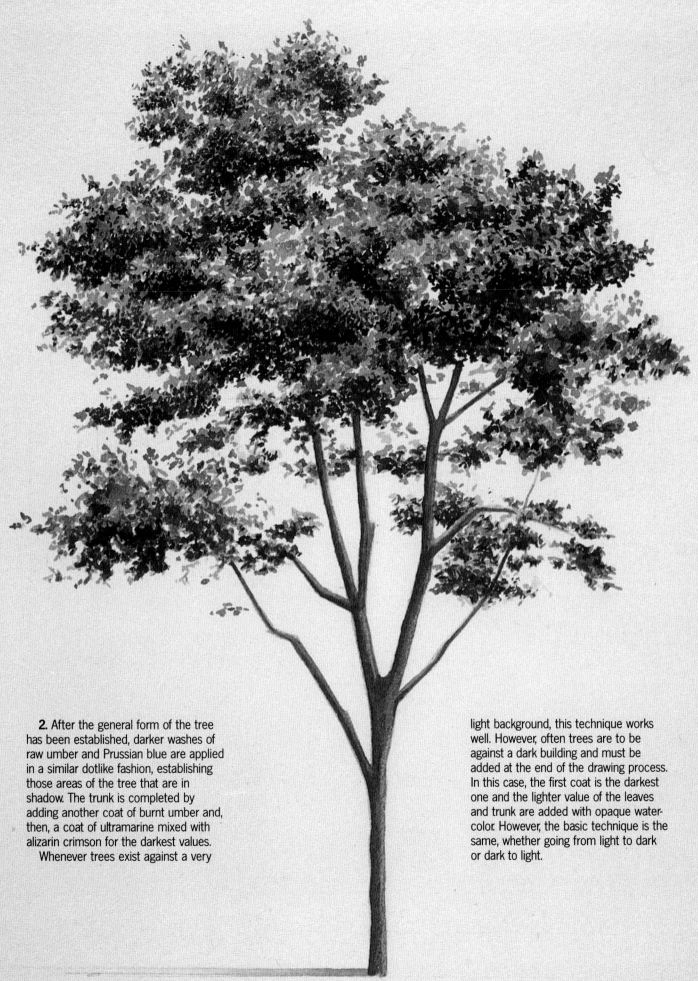

2. After the general form of the tree has been established, darker washes of raw umber and Prussian blue are applied in a similar dotlike fashion, establishing those areas of the tree that are in shadow. The trunk is completed by adding another coat of burnt umber and, then, a coat of ultramarine mixed with alizarin crimson for the darkest values.

Whenever trees exist against a very light background, this technique works well. However, often trees are to be against a dark building and must be added at the end of the drawing process. In this case, the first coat is the darkest one and the lighter value of the leaves and trunk are added with opaque water-color. However, the basic technique is the same, whether going from light to dark or dark to light.

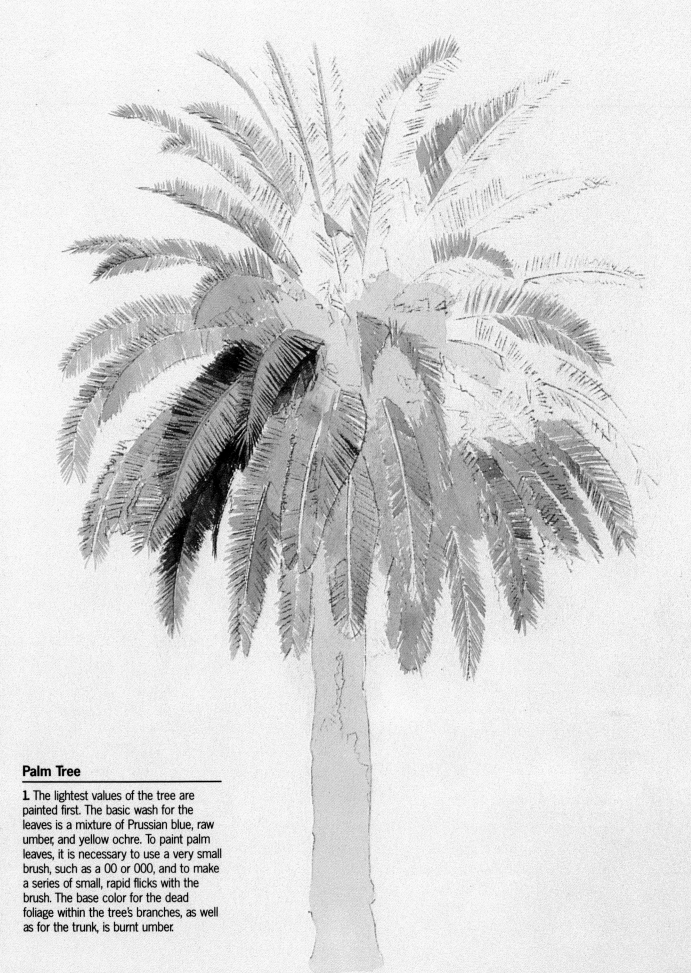

Palm Tree

1. The lightest values of the tree are painted first. The basic wash for the leaves is a mixture of Prussian blue, raw umber, and yellow ochre. To paint palm leaves, it is necessary to use a very small brush, such as a 00 or 000, and to make a series of small, rapid flicks with the brush. The base color for the dead foliage within the tree's branches, as well as for the trunk, is burnt umber.

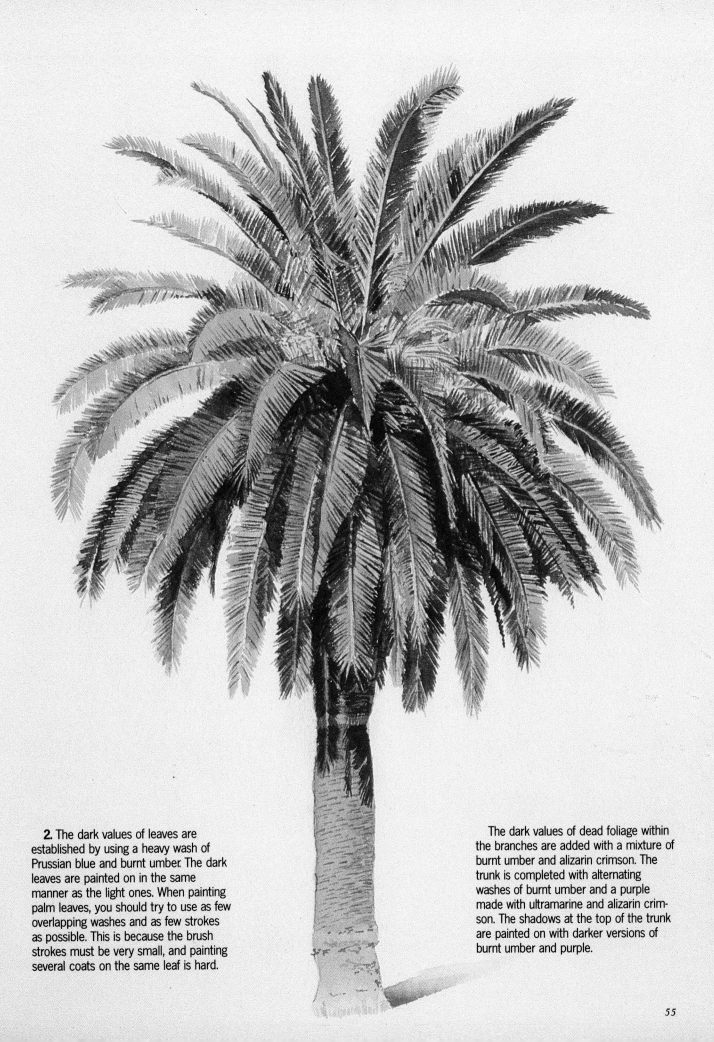

2. The dark values of leaves are established by using a heavy wash of Prussian blue and burnt umber. The dark leaves are painted on in the same manner as the light ones. When painting palm leaves, you should try to use as few overlapping washes and as few strokes as possible. This is because the brush strokes must be very small, and painting several coats on the same leaf is hard.

The dark values of dead foliage within the branches are added with a mixture of burnt umber and alizarin crimson. The trunk is completed with alternating washes of burnt umber and a purple made with ultramarine and alizarin crimson. The shadows at the top of the trunk are painted on with darker versions of burnt umber and purple.

1

PROJECT:
Plaza Las Fuentes
Pasadena, California
ARCHITECT:
Moore Ruble Yudell

1. In this project to the left, all of the drawing has been completed except the palm trees. As most of the values of the background are light, the trees can be painted in using predominantly transparent, rather than opaque, watercolor. In areas where the tree trunks overlap the areas of dark value, the color must first be lifted out. To do this, you first mask the edges of the trunks with drafting tape and scrub out the color with a damp sea sponge. It would have been better to paint around each tree, leaving the trunks white, but it was not known at the time the drawing was started where the trees were to be located.

2. Because it is impossible to scrub out all the color, care must be taken when painting in the trunks. Areas that are dark receive lighter washes at this stage than areas that are light. After the initial washes are laid down, a graded dark wash is added to the right side of each trunk and the details are painted in.

The leaves are added using a dark and a light mixture of Prussian blue and raw umber. Where the leaves overlap a window, an opaque version of the lighter wash is used to paint them in.

PROJECT:
LTV Center
Dallas, Texas
ARCHITECT:
Skidmore, Owings & Merrill

In the project to the right, the client's request for trees presented a problem. If two rows of trees had been added in front of the smaller foreground building, they would have totally obscured its architecture. The "floating tree" solution used here has several benefits—the obvious one being that it shows the viewer where trees are located without covering up the building. It is also a solution that added to the already surrealistic tone of the drawing. In this way, the floating trees satisfied the client's needs as well as the artistic ambitions of the illustrator.

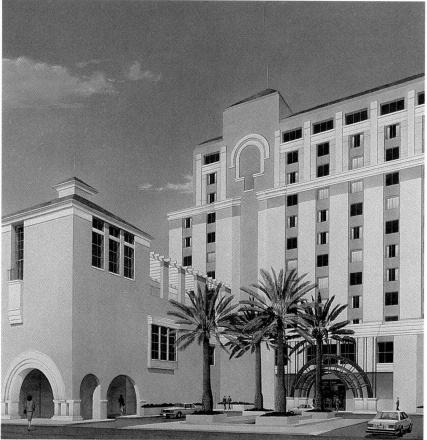

2

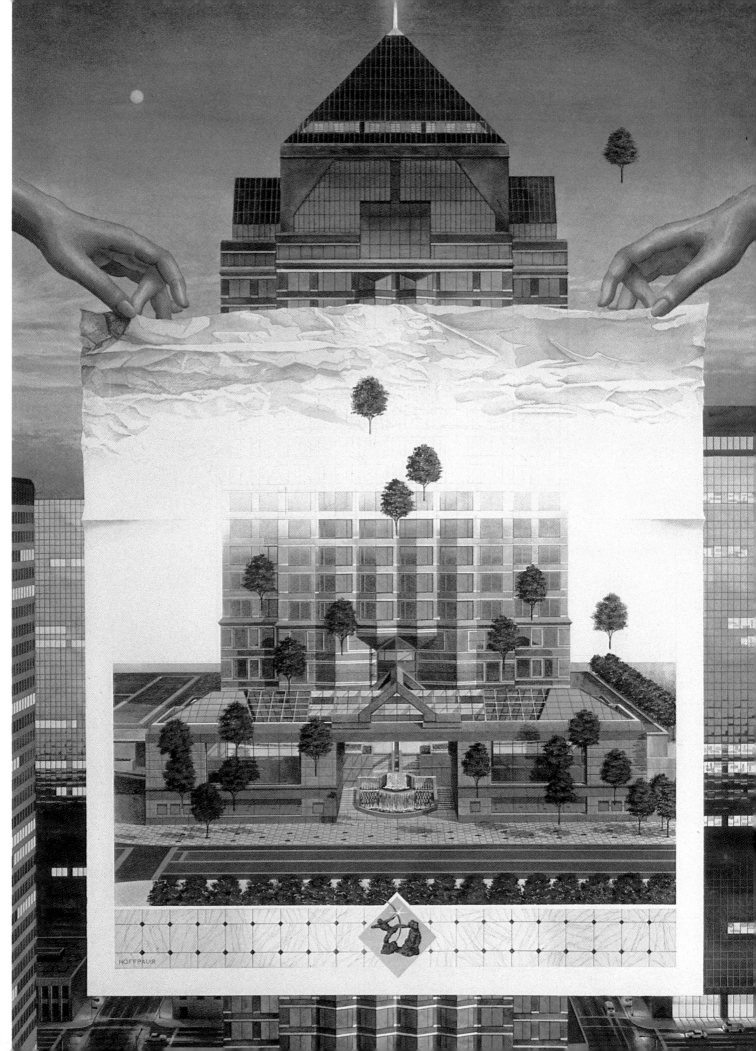

HOFFPAUIR

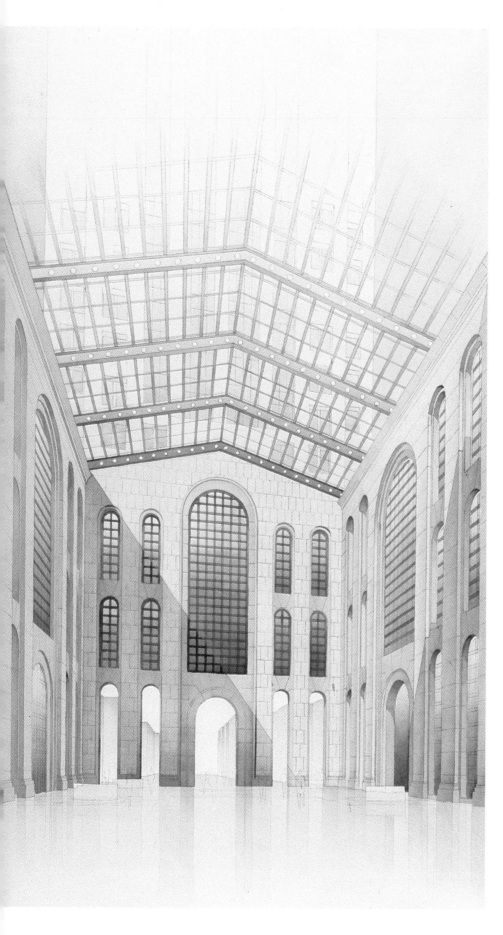

PROJECT:
191 Peachtree Tower
Atlanta, Georgia
ARCHITECT:
John Burgee Architects

This project illustrates a situation that will be encountered frequently. This is the lobby of a high-rise building, and the space portrayed is quite large and austere. With the addition of trees, however, the scale becomes more human, and the space itself seems less severe. The trees also introduce new colors to the drawing. Thus, not only would these trees enhance the space in reality, but they also help to make the drawing more successful.

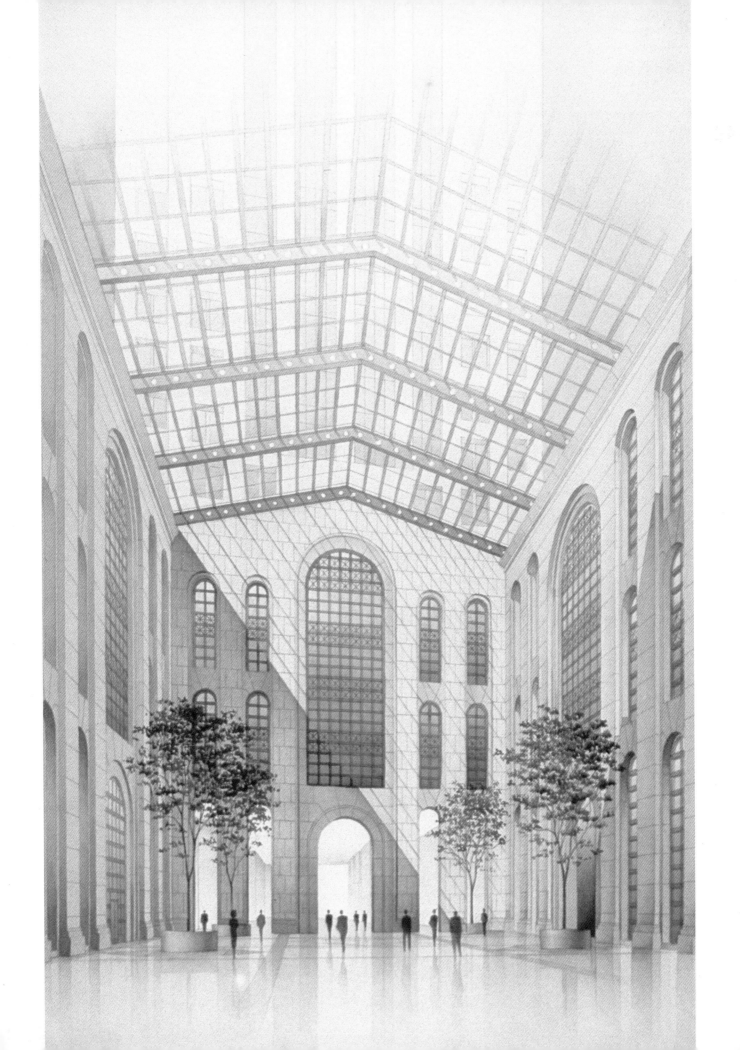

PEOPLE

Most designers like to include people in their perspective drawings. The occasional human being or two, well placed and well executed, will give a better sense of scale to a drawing, or help to balance a composition. The reflection of a man standing on a marble floor might be the only indication that the floor is a polished surface, for instance. People can lend a sense of mystery and wonder to a drawing. A really vast rotunda might appear small and insignificant without a few human figures to give some suggestion of its monumental volume.

On the other hand, nothing dates a drawing faster than the people in it. Fashions in clothing change much more rapidly than fashions in architecture, and a densely populated drawing can look trite and out-of-date in just a few years. A client will often insist that an illustrator add many human figures to a drawing, with the notion that this will add life to it. This is often uncalled-for. It is ultimately more effective and rewarding, although more difficult, to achieve a sense of vitality via the careful modulation of light, shadow, and color.

In architectural drawings, emphasis should be given first to the architecture. Embellishment with human figures should be kept to a minimum. Any figures used should be drawn as carefully and competently as possible, and should be essential to the composition of the drawings.

Unless you are particularly talented or have taken courses in life drawing, the competent rendering of figures freehand is not apt to come easily. Tracing figures from magazines or catalogs could be the solution. You might want to create your own file of people from snapshots or slides. Or photograph people on the street, discreetly, using a telephoto lens. These photographs can then be traced, and the tracings enlarged or reduced by a photocopier according to your needs.

In most instances, the human figures you will be drawing will be no more than 3½ inches high. Therefore, facial features and details can be kept very simple. For Caucasian and Asian flesh tones you can use burnt sienna for the base coat, and create shade and shadow on the faces with a combination of alizarin crimson and burnt umber. For very dark complexions the basic color is created by mixing burnt umber with a small amount of alizarin crimson. Shade and shadow are painted in with a mix of ultramarine and alizarin purple.

For large figures, greater care must be taken and more colors used. For flesh tones in these cases, a very light wash of alizarin would be laid down first, followed by a light wash of cadmium orange. The alizarin would not be painted over in highlighted areas such as cheeks. The whites of the eyes would be painted with a pale ultramarine. Medium and dark skin values would be added with alizarin and burnt umber.

The accompanying two sets of illustrations are good examples of moderately complex figures. At 7¾ inches, they are taller than the figures that populate most drawings, but shorter than some we have used in the past. The technique used to create them can be modified to suit smaller figures by decreasing the amount of detail and the number of washes. Larger figures are rendered by adding more detail and using more colors. Both of these illustrations are based on photographs and, in fact, were traced from the photographs. While the colors used are quite similar to those in the photographs, the colors were modified, particularly the shadow colors, to produce more interesting color compositions.

As has been mentioned, people shown in architectural perspectives are not usually drawn as large as those previously illustrated. It is far more common for human figures to be no more than two-to-four inches tall, as shown in the following examples. Human figures not only help to determine the scale of a room or building, but also to convey the nature of certain materials. In the illustrations that follow, you will note how the reflections in the floor of people standing in that space help the floor material to "read" as polished stone.

PROJECT:
Cody Memorial Library Addition and Renovation Southwestern University Georgetown, Texas
ARCHITECT:
Skidmore, Owings & Merrill

In architectural drawings, one is accustomed to seeing buildings as the feature and people as subsidiary elements. In this illustration, however, that relationship is reversed. This is a watercolor drawing based on Raphael's *Marriage of the Virgin*. The client, an architect, had wanted us to render an isometric of a portion of a university library he had designed. In studying the design, we discovered that the proportions of the new building were similar to those of the temple in Raphael's painting. We were able to convince the client that a more interesting approach would be to recreate the entire painting in watercolor, substituting his design for the original temple.

A drawing was first made of the foreground figures, the paving, and the background landscape. A perspective drawing with the horizon line at the appropriate height was made of the new design, and the two drawings were traced together.

The flesh tones of the figures were created by laying down light washes of alizarin crimson and were refined with subsequent washes of burnt sienna. Cadmium red and cadmium orange—colors we seldom use in architectural drawings—were used to render the bright fabrics. The intricate gold brocade on some of the figures' clothing was painted on with a small brush using a thick mixture of Chinese white and yellow ochre.

We like to think of this drawing as a sort of visual riddle. Although the building is in the background and occupies less than half of the overall area, it remains the focus, as the viewer looks at the drawing and tries to determine what makes it different from the painting that inspired it.

1

2

3

Man in a Suit

1. In this first example, the darkest values of the clothing will be painted in first. This is a reversal of the sequence one usually follows with watercolors. If a gray wash were put down first over the entire suit, the pencil guidelines for the shadows and folds of the cloth would become invisible.

2. A very dark, thick purple made of Prussian blue and alizarin crimson is used for the dark underpainting. This creates a very neutral but interesting color, to be used for all the shadows and folds of the cloth, as well as for dark facial features such as the moustache, eyebrows, and eyes. A much diluted version of the same color is used to lay

in a wash for the jacket and hair. The tie is painted in with alizarin crimson.

3. Before proceeding with the suit, it is important to make sure that shadow areas are quite dry. Because the wash used is very heavy, the pigments will have a tendency to sit on top of the paper rather than soak into it. If not totally dry, the purple will run and smear badly when the next wash is laid on top. The drying process can be greatly speeded up with the help of a hair dryer.

A bluish gray wash made up of ultramarine and burnt umber is painted over the entire suit. Shadows on the white shirt are created with ultramarine.

The face and hands are washed with burnt sienna, and strands of hair are painted in with the dark purple. The suit is complete when two dabs of Chinese white are used for the buttons. Shadows on the tie are painted in with light purple, as are the darker values of the shirt shadows. A writing pen is indicated in the shirt pocket (the model for this drawing was an engineer). The face and hands are completed with a mixture of alizarin crimson and burnt umber. Finally, the figure touches the ground when an ultramarine shadow graded with purple is painted in.

1

2

3

Woman in a Raincoat

1. As with the previous example, shadows are painted in first. For shadows on the raincoat, skirt, and shoes, a bright purple made of ultramarine and alizarin crimson is used. This color complements very well the burnt umber that will later be used as the basic color for raincoat and skirt. The darkest shadow areas on the raincoat are also graded with burnt umber, to give them added depth. The purse is painted with a bluish gray made of ultramarine and burnt umber. Highlights on the purse are left white. Shadows on the ankles are painted with

burnt umber and graded with alizarin crimson just below the skirt. The hair is given a preliminary wash of raw sienna.

2. The raincoat is given its flat wash of burnt umber, and the skirt is washed with burnt umber mixed with burnt sienna. The purse is completed with a coat of Prussian blue, the shoes with alternating coats of burnt umber and the premixed purple. The flesh tones are created by mixing burnt sienna and alizarin crimson.

The skirt and ankles are darkened with more burnt umber and alizarin crimson. The intense alizarin crimson helps to

keep the color composition interesting, and creates more chromatic brilliance. It seems at this point that there should be more contrast between light areas and shadows.

3. Shadows on the raincoat are selectively darkened using alternating graded washes of purple, burnt umber, and alizarin crimson. Strands of hair are painted with burnt umber, using a very fine brush. The darkest portions are then painted in with alizarin crimson. An ultramarine shadow graded with purple completes the drawing.

1

2

3

PROJECT:
**International Square
Washington, D.C.**
ARCHITECT:
**Keyes Condon Florance
Architects**

1. Utilizing the principles described in the preceding examples, the figures are begun by painting the darkest values of their clothing first. Faces are painted with a light wash of alizarin crimson. The hair of the woman and the man in the center is painted with a light wash of raw sienna. The hair of the man on the right is painted with a wash of Prussian blue.

2. The woman's dress is painted with a mixture of Prussian blue and alizarin crimson; her purse and belt with a darker version of this mixture. The clothes of the man to the left are painted with a wash of raw umber. The suit of the other man is painted with Prussian blue, and darkened with the same mixture as used on the woman's purse and belt.

3. The granite floor is added by masking all areas not to be painted and sprinkling a dark gray wash over the entire floor area with a toothbrush. It is the reflections that will make this floor look polished and shiny. Reflections of light objects are created by masking the reflecting areas of the floor with tape and

lifting out the watercolor with a damp, not wet, sponge. Reflections of dark objects are created by darkening the areas of the floor where they occur.

To create the reflections of the people, it is necessary to first draw a mirror image of their outlines on a piece of tracing paper. This drawing is then turned upside-down and transferred onto the floor with a piece of white transfer paper. It is then quite easy to see the white lines against the dark background. The reflections are created by either lifting out the watercolor or painting in with more floor color. After the reflections are completed and the paper is dry, the joint lines are drawn in with a white pencil.

4. Here is the completed drawing. Notice how the colors of the clothing were chosen to blend with the colors of the materials of the room. The color of the woman's dress echoes the color of the gray marble walls. The color of the central figure's suit is repeated in the darkest values of the elevator doors and planters. Finally, the suit of the man on the right is the same color as the dark metal frame of the desk behind which he is standing.

4

FURNITURE

Furniture can be a vital element in an architectural interior perspective. The furniture is an integral part of the space itself, and must be drawn as carefully and accurately as any other element in the drawing.

1

2

3

Tables and Chairs

PROJECT:
USAA Executive Dining Facility
San Antonio, Texas
ARCHITECT:
The Whitney Group, Inc.

1. To establish this drawing's basic color scheme and values, the background furniture is painted in first. Because this corresponds to a relatively small area, the background can be done fairly quickly. Next, the foreground tablecloths are painted with a very light wash of ultramarine. Because this wash is so pale, there will be none of the streaking so characteristic of darker ultramarine washes. This wash will appear white when the drawing is complete.

The seats of the chairs are painted with a gray-green made by mixing Prussian blue and raw umber. A bit of alizarin crimson added to this mixture dulls the

greenish tint, darkens the color, and makes it appear more gray. The frame of the chair is painted with a mixture of burnt umber, alizarin crimson, and burnt sienna. The chairs in the background are painted darker than those in the foreground to help them recede and to draw more attention to the foreground.

2. The sides of the tablecloth are washed with a very light purple made by mixing Prussian blue and alizarin. The folds on the right-hand side of the round foreground table are then painted in with multiple washes of burnt umber and a darker version of the Prussian/alizarin purple. Burnt umber gives more chromatic variety to the cloth than it would have had with the purple wash alone. The left side of the tablecloth is left unfinished at this point. The china is painted, first with a purple wash of

68

Prussian blue and alizarin crimson, as shown on the square table on the left, and then completed with alternating coats of ultramarine and Prussian/alizarin purple. The flatware and stemware are painted in a similar manner. Highlights on the china are created with lines and dabs of thick Chinese white.

The spokes of the chair are painted in using a brush held against an adjustable triangle to ensure straight lines. The color of the spokes is created by mixing alizarin crimson and burnt umber. The color must be dark enough to cover up the seat-cover color underneath, but not so dark as to appear black. The same color is applied to the backrests and armrests, to suggest their tubular shapes. The wood graining of the chair legs is achieved by painting parallel lines of a dark alizarin crimson/burnt umber mix

and a Prussian blue/alizarin crimson mix with a very fine brush. The graining is then washed over with a light mixture of alizarin crimson and burnt umber, leaving some streaks of the original light under-coat to show through. The dark sides of the chair legs are painted in with dark graded washes of the same colors as used for the graining.

The carpet is painted in with a much darker mixture of the same colors as used in the seat covers: Prussian blue, raw umber, and a touch of alizarin crimson. The shadows on the carpet from the chairs and tables are laid in with a coat of Prussian blue.

The stainless steel table base is painted by first laying in a light ultra-marine wash, then painting in alternating coats of the colors used for the china.

3. This illustration shows a detail of the

completed drawing. Prior to completion, the client requested that flowers be shown on the tables. A low arrangement was used, so that the intense colors of flowers and leaves would contrast nicely with the light background of the table-cloth and china. Highlights were added to the glasses with Chinese white, using a very fine brush. The left side of the foreground tablecloth was completed with graded washes of Prussian/alizarin.

The dark edges of the chair spokes were sharpened with a mixture of ultra-marine and alizarin crimson, applied with a ruling pen. The light edges of the spokes were drawn in the same way, using the basic chair colors mixed with Chinese white. Finally, the carpet shad-ows were selectively darkened, using graded washes of ultramarine mixed with alizarin crimson.

FABRICS

Although fabric is not a typical architectural material, it is often a component of interior illustrations. The fabric encountered may be a very simple item, such as a wall panel, or it may have a very detailed pattern and many folds. Whatever the case, it must be rendered with precision.

Cotton Bedspread

1. In this illustration, everything else in the room is completed before the bedspread is begun. As the cotton bedspread is the most detailed element in the drawing, all other values should be clearly established first. In cases in which a room's furnishings are somewhat mundane, it is important to create visual interest by paying attention to the lighting conditions, keeping focus on the lighting rather than on the furniture.

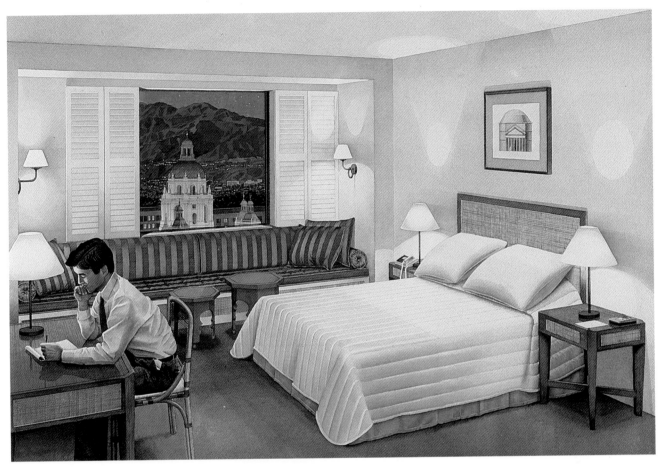

2. Although there are many light sources in the room, it can be assumed that the lamps on the bedside table are the primary light sources for the bedspread. This means that the top of the bed will be brighter than the sides, and that the top and sides will grade darker in the areas farthest away from the lamps.

Before the pattern is painted on, an underpainting of alternating graded washes of ultramarine and purple is applied. These colors are used elsewhere in the drawing to render white surfaces, such as the shutters and walls. This underpainting establishes the light and dark values of the bedspread. You will notice that the washes, particularly for the top of the bed, are not perfectly graded. It is because the fabric pattern to be added later will obscure any imperfections in the graded washes.

3 (overleaf). Photographs of the sample fabric are studied, and the pattern is carefully painted on using 00 and 000 brushes. Washes for the sides of the bedspread are darker than those for the top. Needless to say, such a detailed approach is very time-consuming, but the results can be quite striking.

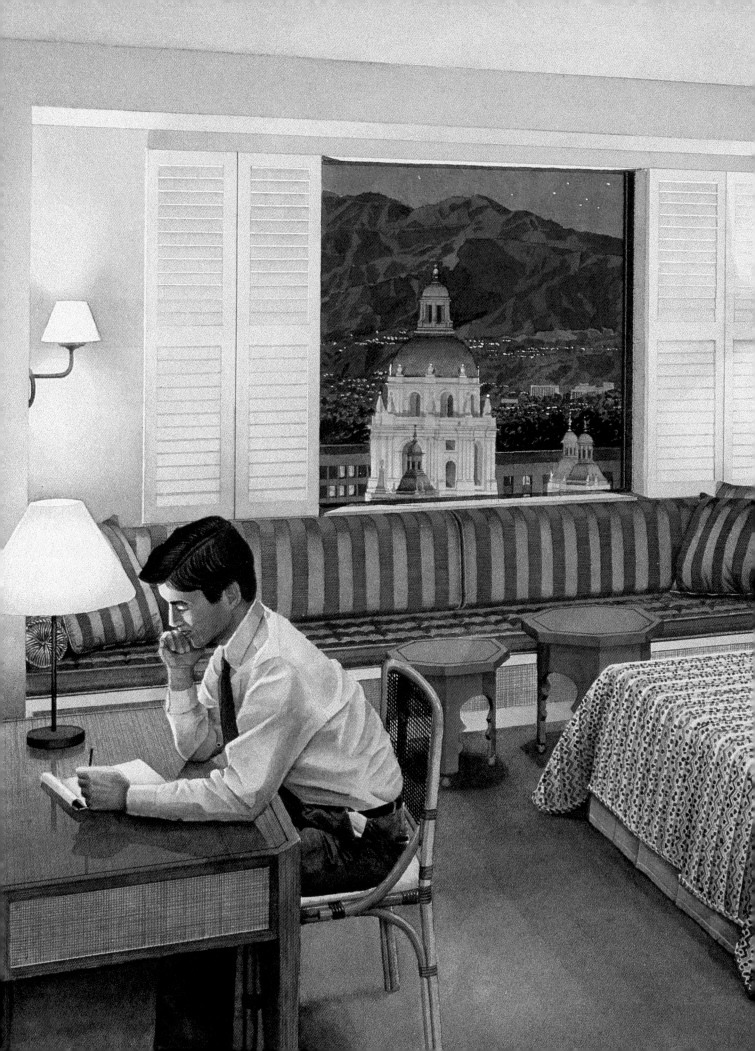

6. BUILDING AND FINISHING MATERIALS

ALTHOUGH A wide variety of building materials is available to architects, we have chosen to illustrate here only those that are used most frequently. By learning to render these with accuracy, you will have acquired the skill and knowledge to illustrate many others.

GLASS

Glass is the single material universal to almost all buildings. When drawing practically any building, you will have to render glass convincingly. For this reason, it is necessary to understand the unique visual characteristics of glass. The most striking—and to many the most startling—characteristic is that one never sees shadows on glass. If you were to look at a hotel with balconies, for example, and saw what appeared to be shadows on the

windows, you would actually be seeing shadows on the window coverings behind the glass. When a window is recessed from the face of a building, you do not see the shadow caused by that recess, but rather the reflection in the glass.

There are two basic kinds of glass: clear and reflective. Clear glass is found in older buildings, buildings that are two stories in height or less, most residences, and the ground floors of modern high-rise buildings. Although they are transparent in most daylight situations, in illustrations clear glass windows appear to be little more than dark voids. With them, you will be able to see objects near the inside face of the glass, as well as all inside light fixtures, but little else of what lies beyond.

All glass is somewhat reflective; therefore, in addition to seeing objects and lights behind glass, you will be able to see reflections of objects in

front of the glass. In outdoor situations, these reflections are of cars, pedestrians, trees, and so forth. In indoor situations—a corridor looking into a glass-enclosed office for example—reflections generally are much less prominent, and likely would not be visible at all.

Reflective glass is used in large modern office buildings for exterior windows above the first or second story. You cannot see through reflective glass to the interiors of buildings in bright daylight as you can with clear glass. You see only the reflections of the sky and the surrounding buildings.

Although reflective glass can vary in color from bright pink to intense green, most glass of this type is manufactured in varying shades of gray. It is difficult to predict the apparent hue a glass will have when it has become a building material by simply looking at a glass sample. A more accurate way

to determine how to render a particular type of reflective glass is to find a structure for which that type was used. Photographs in manufacturers' catalogs can be particularly helpful. As a general rule of thumb, when a glass surface reflects the sky, the color of the glass will be somewhat darker and grayer than the sky itself. In our own work, we generally use Prussian blue mixed with a small amount of alizarin crimson as the base color for reflective glass. Reflections of surrounding buildings we render with a more intense version of the same basic mixture.

If you were to look at a photograph of a metropolitan skyline taken on a clear day, you would notice that the blue of the sky becomes more intense as your eye moves upward from the horizon line. As the glass of a high-rise building reflects the sky, you would notice that, similarly, the color of the glass deepens as you move up the building. One way to achieve this effect in a drawing is to darken the topmost panes of glass with purple washes made of ultramarine and alizarin crimson. This will deepen the color of the glass without actually turning it purple.

Glass will take on different visual characteristics depending not only on its type, but also on the general level of lighting, the time of day, and the context in which it is located. You should make a point of observing glass in different circumstances in order to better understand how to render it convincingly.

The illustrations that follow present two views of a project in Washington, D.C. The first set of illustrations shows a multi-story office block with reflective glass windows. As reflective glass is in general easier to render, this process is discussed first. The second set of illustrations shows a different view of the same project, but focuses instead on the two-story clear-glass building in front of the office building.

1

PROJECT:
1100 New York Avenue
Washington, D.C.
ARCHITECT:
Keyes Condon Florance
Architects

Reflective Glass

1. At this stage, almost the entire area surrounding the office building has been painted in. The building to the right has been painted to show the reflection of the surrounding office buildings in the glass. The reflections of these buildings as well as the sky are painted in varying shades of Prussian blue mixed with alizarin crimson.

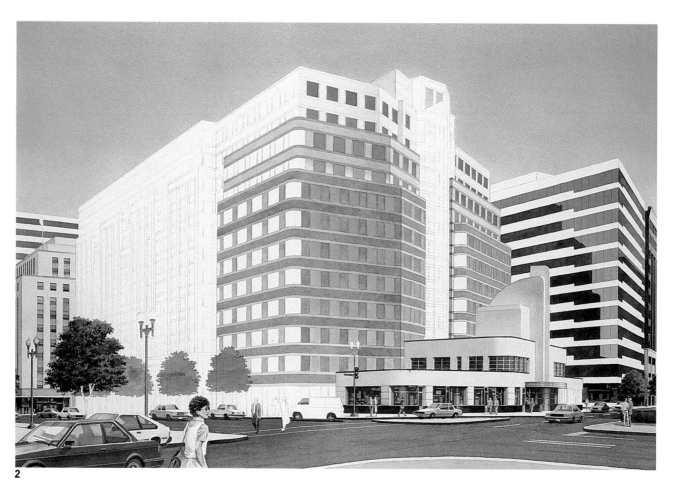

2

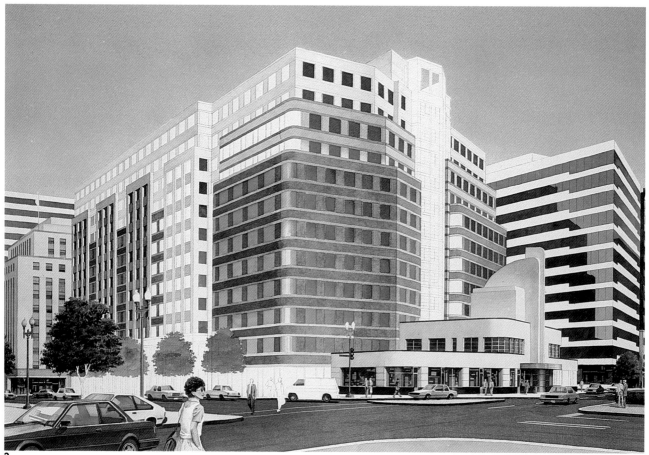

3

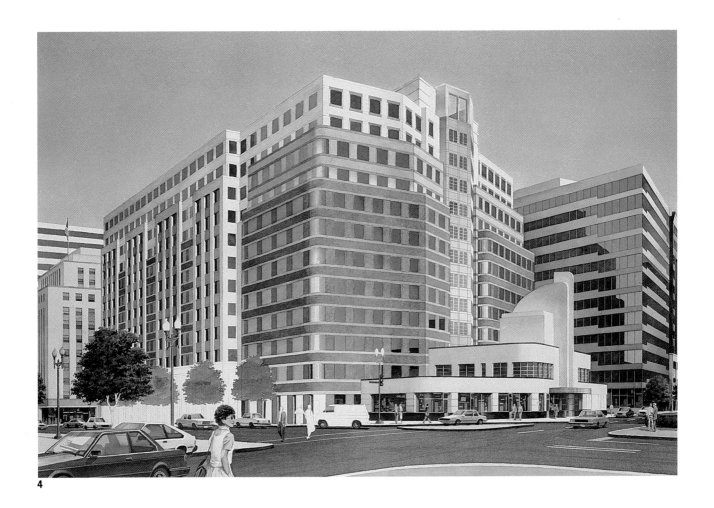

4

2. In this instance, as with most multi-story office buildings, the spandrels and columns are painted in before the glass. The glass is painted with the same Prussian blue and alizarin crimson mixture used earlier. The glass is graded darker toward the top of the building. The top floors are darkened with a purple made of ultramarine and alizarin crimson.

3. You will notice that the glass is darker on the light side of the building (the side not in shadow), and lighter on the dark side. This is a common phenomenon that helps to give glass its shimmery appearance. The rounded corner pieces are painted with graded washes to create a vertical highlight that accen-

tuates the curve of the glass. At the left rear, the columns, spandrels, and recessed windows are begun.

4. The left side of the building is almost complete. The glass on this side is painted in, and the sides of the columns are shown as dark reflections in the glass. Reflections of the two-story building in front are added to the glass panels on the front façade. The central V-shaped vertical bay of windows in the front is painted in, and the mullions in this bay are drawn in with Chinese white. Mullions on the building on the right are drawn with white colored pencil over the dark reflection and with Prussian blue over the sky reflection.

5. After all other details have been added, mullions are drawn around all windows with Chinese white loaded into a ruling pen. Because the windows on the ground floor are of clear glass, they have been rendered in a manner similar to that used for the windows of the two-story building.

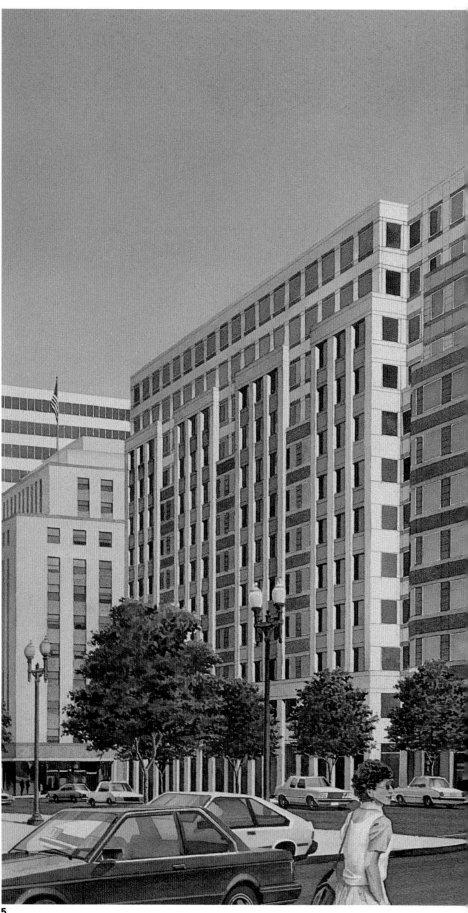

5

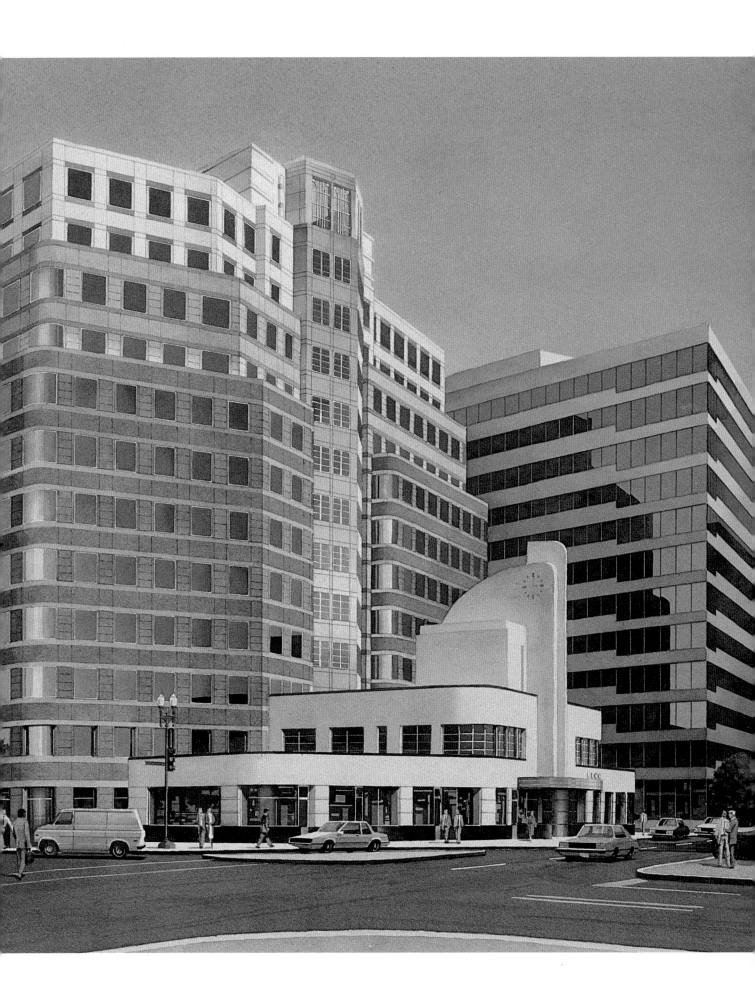

1

2

Clear Glass

1 and 2. At this stage of the drawing, the reflective glass windows of the office tower have essentially been completed. The windows of the second story of the low-rise building are painted first with a wash of Antwerp blue. It is assumed that there are cloth shades behind the second-story glass. Although shadows do not fall on the glass, they would fall on the window coverings behind, so shadows are painted on the shades with Prussian blue mixed with alizarin crimson.

The ground-floor windows must be shown without window coverings, so it is necessary to give some indication of what lies behind the glass, as well as an indication of street-level reflections in the glass. Because the windows in the background appear smaller and less complex than those in the foreground, they are painted first. A base coat of Antwerp blue is laid down. To suggest objects behind the glass, horizontal and vertical rectangles of varying sizes are drawn, and the area surrounding these shapes is painted in with a dark mixture of Prussian blue and alizarin crimson. Reflections in the glass are suggested by alternating darker and lighter bands across the entire face of each pane.

3. Because of the greater complexity of the windows in the foreground, it was necessary to take snapshots of various storefront windows in order to have models to use as guides in rendering the windows. Windows that had strong patterns of light and dark areas were photographed. Since there is a landscaped median across the street from this building, it was important to photograph windows that also had tree reflections. The foreground windows are rendered in the same colors as the background windows. The second-floor windows are completed by adding shadows from the horizontal and vertical mullions, and then by drawing the horizontal mullions with Chinese white loaded into a ruling pen.

4 (overleaf). This shows a detail of the finished drawing.

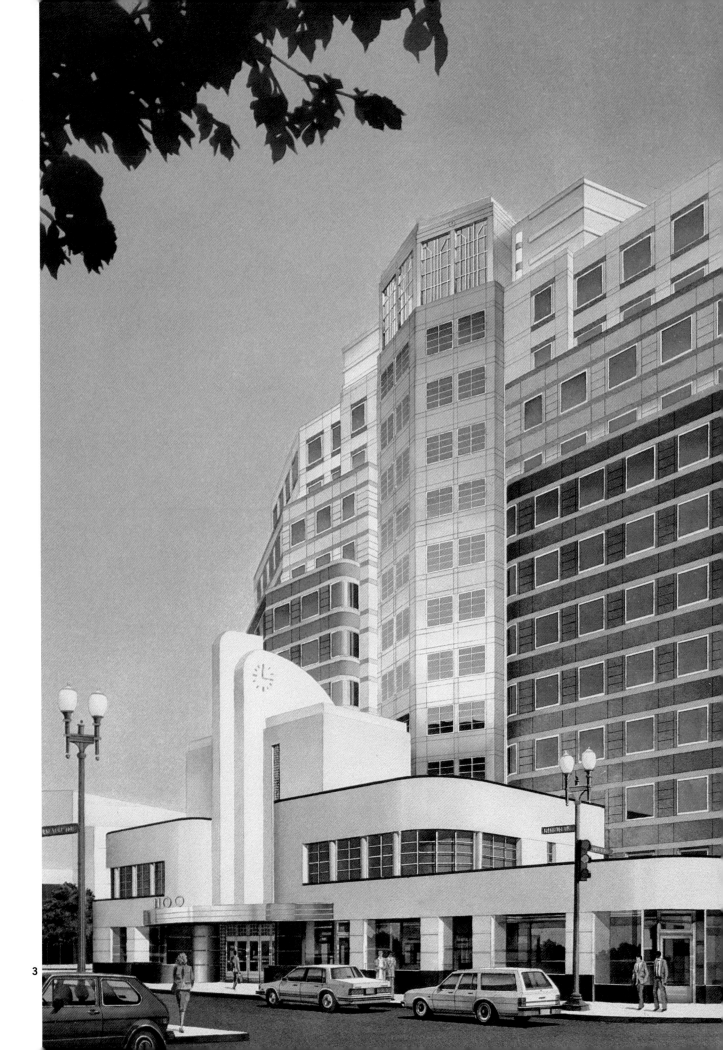

PROJECT:
1100 New York Avenue
Washington, D.C.
ARCHITECT:
Keyes Condon Florance
Architects

This is a drawing of a portion of a building, undertaken to illustrate the different types of stone, fabric, glass, and metal panels to be used on the building. The glass in the windows of the top two stories, as well as that of the windows in the central recessed portion, is reflective. All other glass is clear. The reflective glass in this instance has a pinkish cast, which is visible in the lower left half of the fourth-floor windows. The glass of the center portion reflects the building across the street. Note that the distorted and liquidlike reflections often created by glass panes are rendered here.

In the second-story center window, a reflection of a window with similar proportions is shown. In the ground-floor center window, you see a reflection of a clear glass storefront, which has its own reflections.

In the clear glass window of the third story, you can see a reflection of a building parapet, as well as the ceiling lights of the space behind the glass. In the ground-floor display windows, the reflections are kept simple in order that the displays themselves be featured.

POLISHED BRONZE

When rendering bronze, you can achieve quite striking results with very little effort. Whether the bronze to be illustrated has a polished or a satin finish, the basic approach is the same, and the result is a reflective material with varying degrees of sheen. Architecture and interior design magazines are usually replete with examples of bronze: for example, handrails, elevator doors, and light fixtures. Studying these examples will reveal that the bronze becomes quite light and yellow where it is reflecting light. It is darker and browner where it is in shadow or reflecting a dark material. It is the combination of colors and the way the washes are graded that make the surface appear reflective.

1

Satin-Finished Bronze

In this example, the elevator door is made of a satin-finished bronze. The door is painted in three stages.

1. First, a flat wash of yellow ochre is painted on all areas to be bronze. A second coat of yellow ochre is used to begin distinguishing those areas that are to stay light from those that are to be dark.

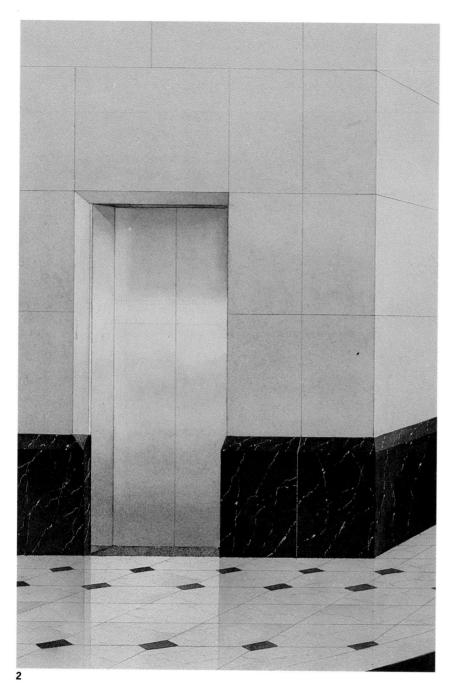

2. Next, raw umber is used over the initial yellow washes and is graded darker at the bottom. The top of the door is also graded darker, as the door is recessed and the top part is in shadow. You will notice that a light area has been left on the door next to the jamb. This indicates the reflection of the jamb in the door.

3. Washes of burnt sienna are then put over the darker raw umber washes to add depth to the color and keep it from looking too brown and too flat. As a final step, two dark lines are added with a ruling pen. One indicates the line where the door meets the jamb, the other the line where the two doors meet. An opaque white line next to the dark center line becomes a highlight where the light hits the edge of the door.

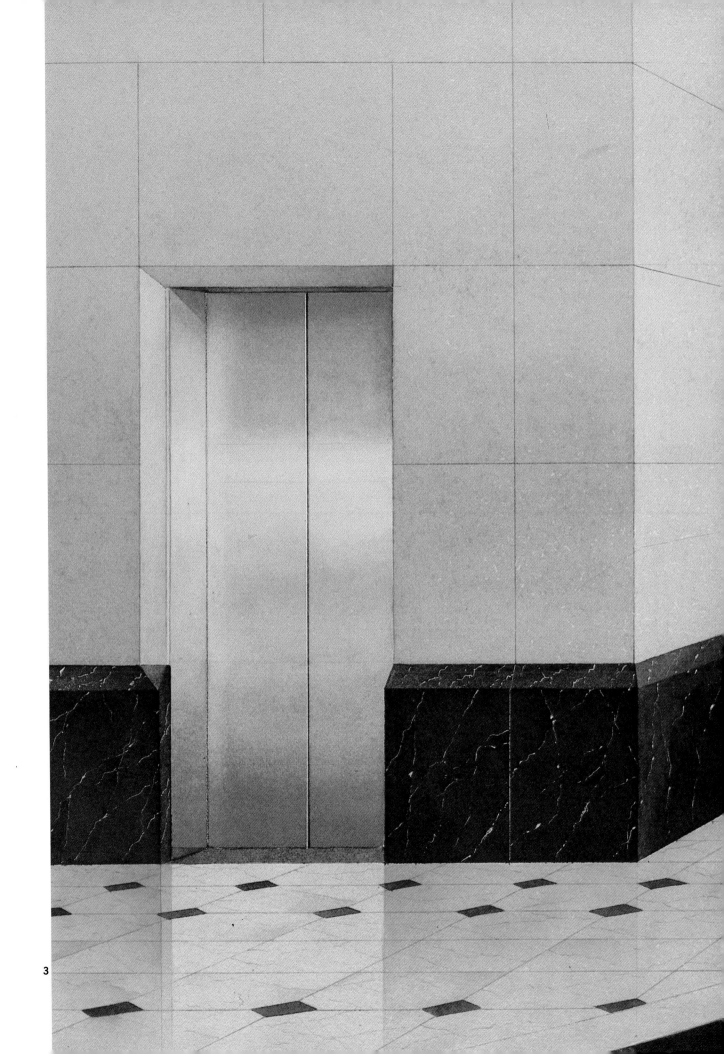

3

PROJECT:
Texas Commerce Tower
Dallas, Texas
ARCHITECT:
Skidmore, Owings & Merrill

This second example illustrates the difference between satin-finished and polished bronze. The main panels of the elevator door are satin-finished, and therefore the gradation of hue and value is soft. The trim strips between panels are polished bronze. Therefore, the bronze here has harder edges and its reflections are more exaggerated. In this example, the distinction between the two finishes is very clear. As a final separation of materials, a colored-pencil joint line is added between the two surfaces.

STAINLESS STEEL

Stainless steel, like polished bronze, has surfaces that range from those that are highly polished and act like mirrors to those that are satin finished, in which reflections are softer and more diffuse. Because it requires frequent cleaning, highly polished stainless steel is seldom used for large surfaces, but is often used for smaller applications, such as furniture and handrails. Conversely, satin-finished stainless steel, which does not show fingerprints easily, is used in larger applications, such as on the faces of elevator doors.

The principles used in rendering stainless steel in elevation are the same as those used for polished bronze, with the obvious difference being the change in color. You make the switch by using burnt umber in place of yellow ochre, and ultramarine blue in place of raw umber and burnt sienna. As with polished bronze, the highlights are created by leaving a portion of the paper unpainted so that its natural white color shows through.

PROJECT:
Signage Study
ARCHITECT:
Skidmore, Owings & Merrill

In this example, the major part of the sign face has a satin finish. Several diagonal stripes of burnt umber are laid down first. The edges of each stripe are then graded with water; thus, the edges are soft and diffuse. In a similar manner, ultramarine stripes are laid down over some, but not all, of the burnt umber. Applied in this way, both the ultramarine and the burnt umber remain distinct colors. The two colors could have been mixed together to produce a uniform gray with which to render the entire drawing, but this would have produced a monotone drawing with far less chromatic interest. The small square surrounding the blue glass and the "X" in the middle are polished, and, as such, their highlights and stripes are rendered with sharp edges.

The entire drawing was done very quickly to actual size. Because it obviated the need to have a prototype drawing made, it saved the client both time and money.

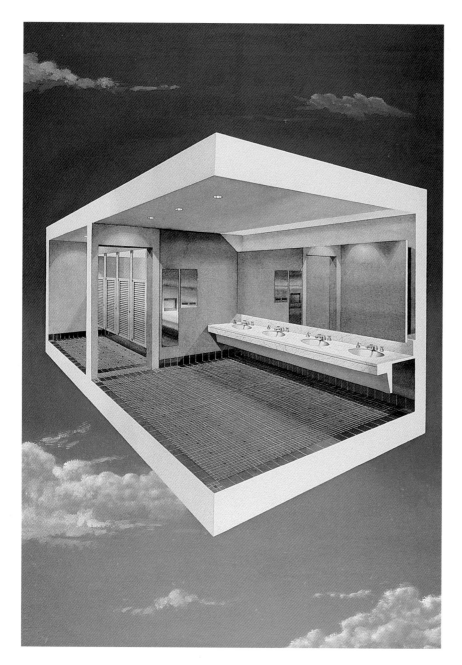

Stainless steel must be rendered somewhat differently in perspective than it is in elevation. Unlike polished bronze, stainless steel is essentially colorless. Aside from its somewhat dull bluish gray cast, the material will take on the colors of what is around it. A highly polished finish would look much like the mirror in this illustration: you would simply see the room in reverse. A satin finish, like that shown here on the wall-mounted dispensers, would act in a similar (yet somewhat different) manner. The reflection of the ceramic tile floor, the green tile base, and the white lavatory top is visible in its face, but the edges of each material's reflection are softer and more diffuse.

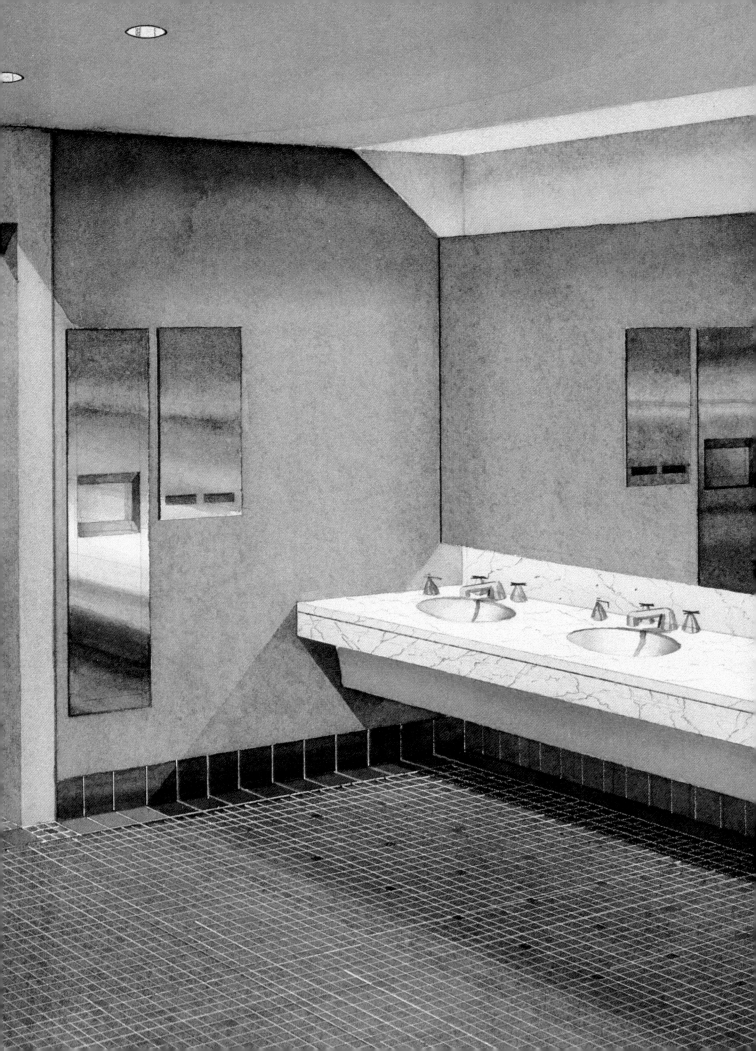

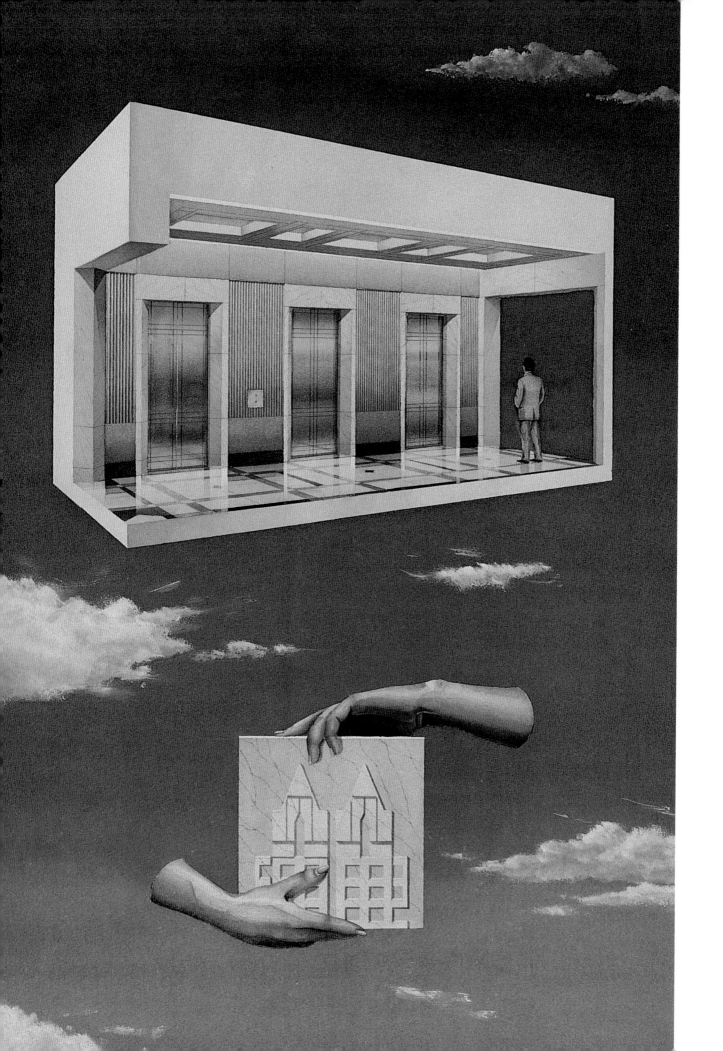

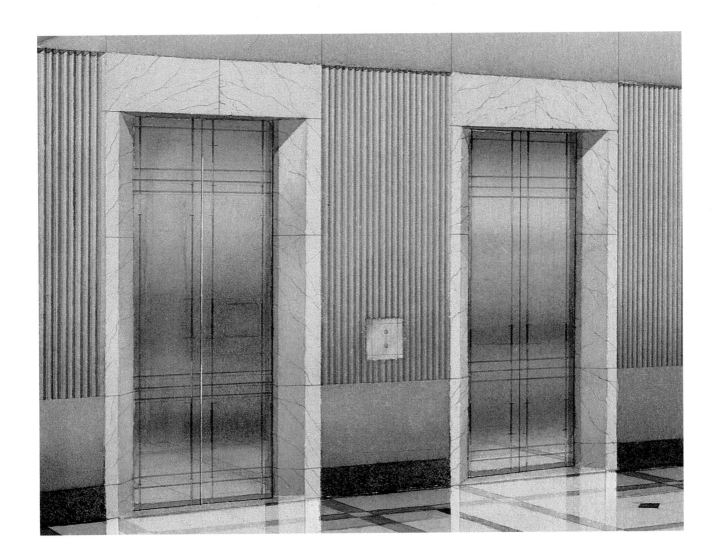

PROJECT:
Sun Bank Center
Orlando, Florida
ARCHITECT:
Skidmore, Owings & Merrill

Stainless steel with a satin-finished surface will reflect planes that meet it perpendicularly. To a lesser extent, it will also reflect planes parallel to its surface. In this example, the primary reflections in the stainless steel elevator doors are those of the floor and door frames. This is particularly apparent in the door on the far left. You can see the reflection of the white and gray stone floor pattern, as well as the reflection of the opposite wall's dark stone base. Above this base reflection, the same salmon color used on the walls of the elevator lobby has been used on the door. Some liberty

has been taken in introducing the horizontal blue bands in the middle and top of the door. With the introduction of contrasting areas of dark value (the blue) and light value (the salmon pink), the perception of a bright sheen in the material is heightened. The blue used here also reiterates the blue of the surrounding sky, and helps to unite the sky and the elevator lobby in a harmonious color composition.

To create the reflective quality seen here, the reflection of each material or band of color is drawn in pencil on the door. Each color is painted in individually, and, before the color dries, its edges are graded with water. When all colors have been painted in and the door is quite dry, the pencil lines are erased. The polished bronze divider strips are then drawn on the door using a ruling pen loaded with burnt sienna.

GRANITE

Rendering granite can be quite time-consuming although it is not particularly difficult. Because granite has an appearance of being made up of many small dots of color, you will usually need to do some initial color studies before beginning the final drawing. In trying to match an existing stone, you should examine a sample of that stone for certain features. The predominant color in the sample will become your base color. After you have applied the base color and it has dried, you apply speckling by lightly flicking a toothbrush dipped in several colored washes (one color at a time) over the relevant area, to establish the variety of dots that make up the stone.

Granite as a building material basically comes in two types of finishes: polished (shiny) and honed (matte). It is the reflective properties that distinguish the polished granite from the honed. After you have selected the palette of colors for the polished stone, the next step is to put in all dark reflections, after which you paint the granite itself.

1

PROJECT:
**USAA Executive Facilities
San Antonio, Texas**
ARCHITECT:
The Whitney Group, Inc.

1. This illustration shows a portion of an interior perspective drawing for a restaurant. The unpainted floor area shown here, as well as the curbed base around the fountain, will be granite. All other finishes have been completed. The stone sample to be matched is a medium-value polished stone that is somewhat grayish blue in color.

2. First, the reflections in the granite are drawn in and painted with a wash of Prussian blue alternating with washes of ultramarine blue and burnt umber. The surfaces of the granite that are in shade, such as the granite curb in front of the fountain, are darkened with the same washes.

2

3

3. Next, a smooth wash of Prussian blue mixed with alizarin crimson is put over the entire area corresponding to granite. This establishes the base color of the stone.

4. The final step is the speckling. Several washes of ultramarine and burnt umber, varying from almost black to light gray, are prepared. All areas not to receive speckling are masked with frisket film. Then, each wash is speckled onto the base color with a toothbrush, until there is an even and consistent dot mix of all colors. The final step is to add dark joint lines with a ruling pen. A white-colored pencil is used to add a highlight at the edge of each square of granite.

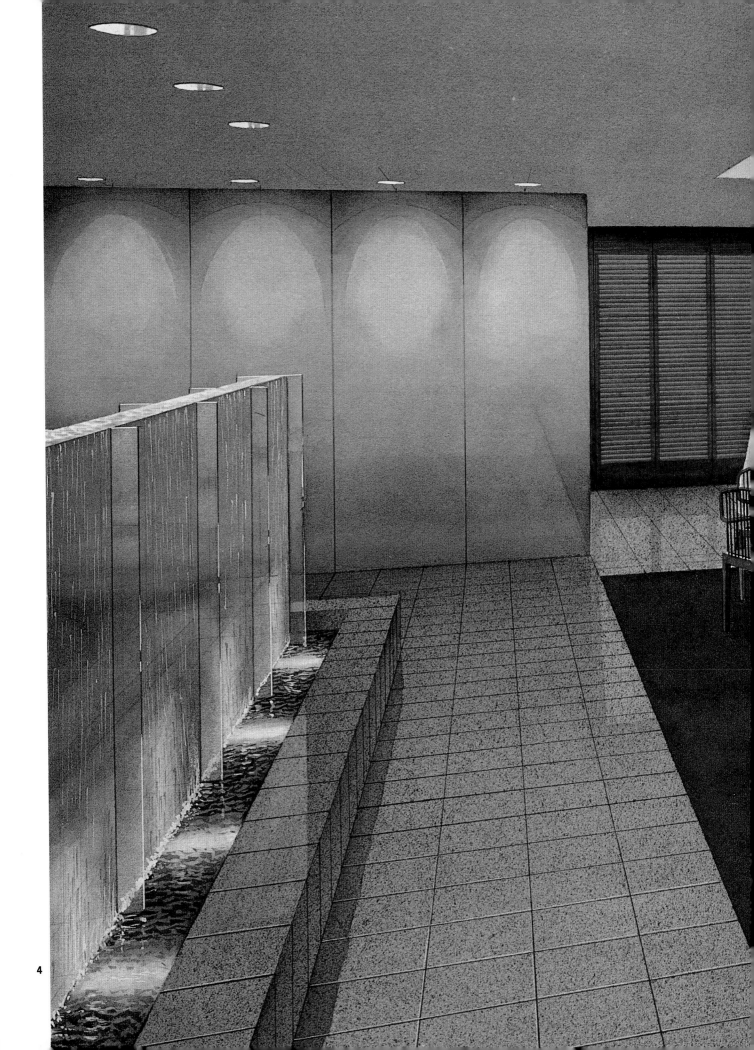

MARBLE

Many people confuse marble and granite. Although both are quarried stones available in a wide variety of colors, only marble is characterized by veining. Granite, when viewed from a distance, looks like a collection of small, multicolored dots. Marble is often polished, and thus deep reflections can be seen in the surface, particularly if the stone is very dark.

In the example that follows, two types of marble were used: white marble for the walls of the elevator lobby and the arch, and a dark green, almost black, marble for the floor. White marble is actually a light gray. In this illustration, the white marble was rendered with a gray that was much bluer than that of the actual sample, in order to heighten the sense of the stone's coolness. The marble of the floor was rendered with a very dark wash that appeared green only when it was lifted out.

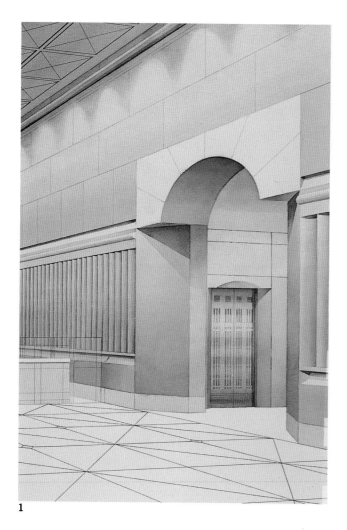

1

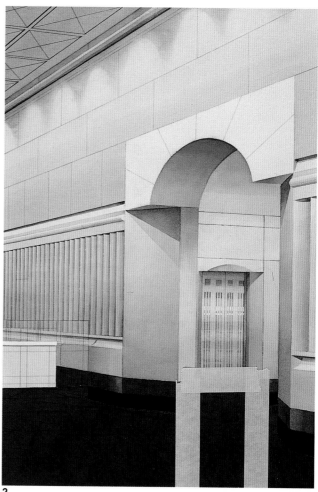

2

PROJECT:
**Texas Commerce Bank
Dallas, Texas**
ARCHITECT:
Skidmore, Owings & Merrill

1. At this stage, nearly all of the drawing is complete except for the marble surfaces. The white marble around the elevator door is painted with a light wash of Prussian blue mixed with alizarin crimson. A few of the smaller surfaces receive a second coat so that they will be distinguishable from the adjoining wall planes. The underside of the arch as well as the shadow adjacent to the elevator door are washed with a darker mixture of the two colors. The areas in shadow are then tinged with deep, graded washes of ultramarine.

The color of the floor is very dark; thus, if the floor wash were painted over pencil lines, the lines would be completely hidden. Accordingly, the joint lines are first drawn with a technical pen and waterproof ink, so that they will be visible through the dry watercolor.

2. A dark wash of Hooker's green and Prussian blue is prepared. Some alizarin crimson is mixed in so that the green is slightly neutralized. Because the wash is so thick, it is applied to the floor in two coats, to avoid streaking. The marble bases are painted with graded washes of the same mixture. Reflections in the floor will either be darker or lighter than the basic floor color. The darker reflections—in this case those of the marble bases—are added with a dark mixture of Prussian blue and alizarin crimson. Light reflections will be created by masking the areas where these reflections are to be, and scrubbing or lifting the color out with a damp sponge. In this photograph you will notice masking or drafting tape in the area where the elevator door reflection is to be.

3. All reflections have either been painted in or lifted out at this stage. Notice that the reflection of the elevator door is the lightest of all reflections, although the door itself possesses a darker value than the surrounding walls. This is done because the bronze doors are treated here as a light source. The bright reflection in this location helps to focus attention on the doors, and to draw the viewer into the elevator lobby. It also reinforces the shimmering quality of the metal doors.

4. Joint lines between pieces of adjoining stones in the floor are drawn with a white pencil. Diagonal joint lines are actually thin bronze divider strips, and are drawn with yellow ochre mixed with Chinese white loaded into a ruling pen. Highlights in the divider strips and the diamond-shaped white stone medallions are added with Chinese white.

Finally, it is time to add the veining. On the white marble, this is achieved by drawing a series of short, interconnected lines with a soft graphite pencil. After the watercolor is very dry, the veins in the dark marble are added by scraping out the lines with the point of a very sharp X-Acto knife.

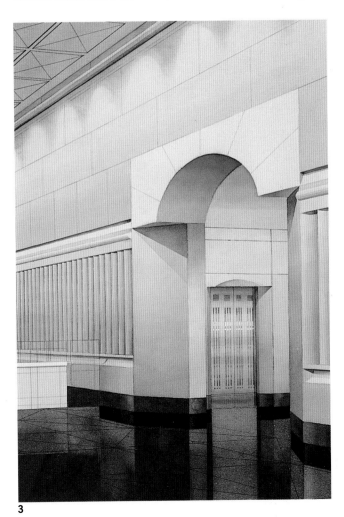

3

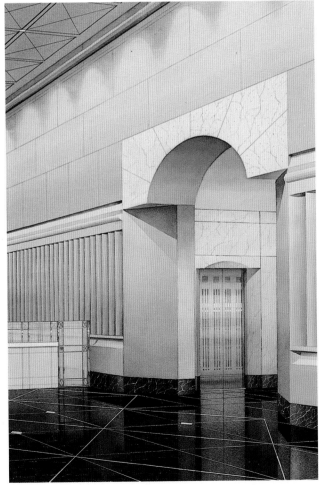

4

5

5. A view (left) of the entire drawing. Note the veining on the planter in the far left foreground. Because the windows are light sources, their reflections are the brightest. It is possible to scrub out the reflections in this area almost to white. (The washes used to paint the floor are so thick that they tend to sit on top of the paper rather than soak into it.)

PROJECT:
Milwaukee Theater District
Milwaukee, Wisconsin
ARCHITECT:
Skidmore, Owings & Merrill

Often, when there is to be a light-colored polished marble, the reflections will take on some of the color of the objects being reflected. In the illustration on the right, the marble floor was washed with lighter versions of the colors used for the wall and column surfaces. The washes were graded to give the impression that the reflections fade away. As in the previous example, a graphite pencil was used to indicate veining. Gray joint lines were added over the areas of stone that appeared light, and Chinese white was used for joint lines over the darker reflections.

BRICK

Brick buildings have a richness of color and texture that is not found in many other buildings. The colors of brick may vary from a light yellow to a deep reddish brown; the texture and pattern of bricks may or may not be apparent, depending on the distance from which they are viewed. If the viewer is quite close to the brick, it is necessary to show all joint lines.

However, brick is usually viewed from a middle range, in which case the horizontal mortar joints are indicated and the vertical ones left out.

Although brick is often a consistent color across an entire building surface, there are instances in which a mixture of brick colors is used to create an overall pattern, as in the example here.

1

2

Drawing Brick

1. The windows are masked out first, and then a wash of burnt sienna mixed with a small amount of burnt umber and alizarin crimson is put over the entire surface. Next, with a graphite pencil, horizontal and vertical joint lines are carefully drawn. (If the bricks are a very dark color, a light-colored pencil may be used for the joint lines.)

2. With a purple wash of alizarin crimson and ultramarine, specific bricks are painted to create a pattern. Shadows on the bricks are added next, with a wash of burnt umber and alizarin crimson. A second wash of purple is put over the darker bricks. After the brick is complete, the windows are painted. A mixture of ultramarine and burnt umber is used for the frames, and Antwerp blue is used for the window shades.

LIMESTONE/CONCRETE BLOCK

Limestone is one of the easiest materials to render in watercolor, regardless of its finish. Often, limestone and concrete are very similar in appearance. As a result, they may be rendered in the same basic way.

When trying to match perfectly a limestone sample, you can use burnt umber and ultramarine blue, mixed to match the gray of the limestone. However, this often results in a rather dull drawing. Consequently, you may find it more desirable to use burnt umber straight out of the tube. Either Grumbacher's or Winsor & Newton's burnt umber will work fine; however, we feel that Winsor & Newton's is the purer and cleaner color.

You can then use a purple of ultramarine blue and alizarin crimson to grade over the burnt umber for shade and shadow. Often, the results are too purple, and it will be necessary to add some burnt umber to the mixture—but this will usually depend on the overall color composition of the drawing.

PROJECT:
**The Brooklyn Museum
Master Plan Competition
Brooklyn, New York**
ARCHITECT:
Skidmore, Owings & Merrill

In this example, the building is depicted as if it were part of a painting in a gallery. The painting is then framed by two limestone pilasters and a limestone wainscot. The limestone pilasters are first painted with a flat wash of Winsor & Newton's burnt umber. Then, all shading and shadows are added with a mixture of ultramarine blue, alizarin crimson, and burnt umber. This is a good example of how—with only three colors and a few steps—the entire pilaster becomes defined.

The Brooklyn Museum Master Plan Competition, Skidmore, Owings & Merrill Board #1. Used by permission of The Brooklyn Museum.

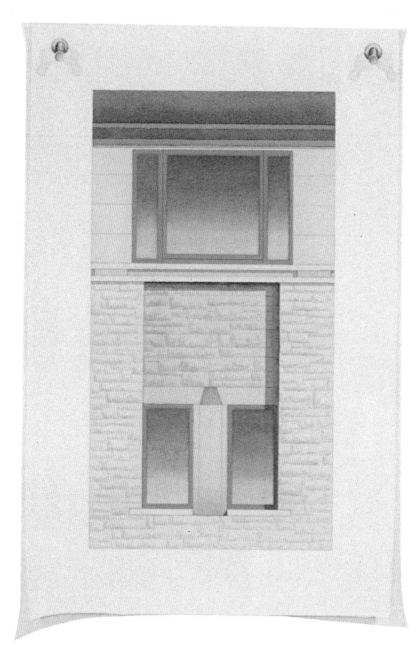

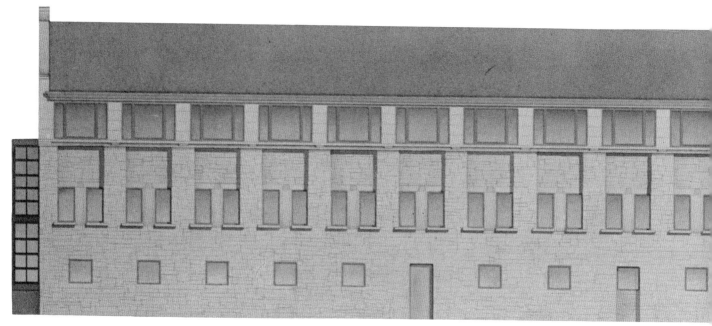

PROJECT:
Cody Memorial Library
Addition and Renovation
Southwestern University
Georgetown, Texas
ARCHITECT:
Skidmore, Owings & Merrill

This next example shows split-faced limestone. As with the smooth-faced stone, a preliminary wash of burnt umber is put over the entire stone area, regardless of its finished surface. (Where planes are recessed, they receive another coat of the burnt umber wash.) Next, a wash of alizarin crimson and ultramarine blue is used to define the rough surface of the stone, by depicting the jagged pieces in shadow on each limestone block. In this drawing, the scale of the overall elevation is too small to actually illustrate the rough surface of the stone. Therefore, a separate drawing at the top serves as an enlarged detail.

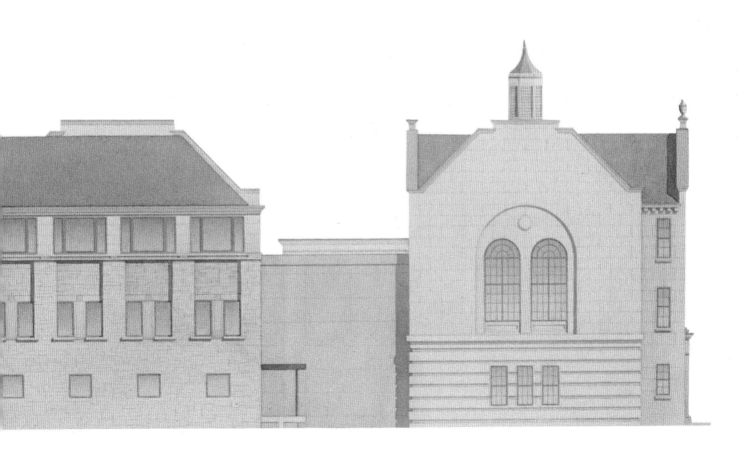

WOOD

Wood is a material that lends itself well to being rendered in watercolor. Like watercolors themselves, the colors of wood have a seeming transparency and depth, and the darker varieties in particular have great nuance and chromatic richness that present an exciting challenge.

Because woods vary greatly in color and pattern, it is useful when depicting wood to have a sample, and perhaps also a photograph, of the particular type to be drawn. Watercolor can be used to render wood very realistically, but it must be kept in mind that this requires a great deal of time and patience. You can gain some confidence and also speed the process along by rendering fully a small sample of the material before beginning the final drawing.

1

PROJECT:
Sun Bank Center
Orlando, Florida
ARCHITECT:
Skidmore, Owings & Merrill

The drawing presented in this sequence of illustrations is an elevator cab with two of its wood-panelled walls removed. The wood to be rendered is pearwood with a medium-dark-value stain. To promote authenticity, a photograph of an actual elevator cab found in an interior design magazine has been used as a model. The photograph indicates that there will be bright ovals of light at the top of each wall, each of these highlights corresponding to a particular light fixture. Overall, the wall will grade from dark near the floor to slightly lighter in the area below the oval highlights.

1. With these considerations in mind, a very pale wash of burnt sienna is painted over one wall. Alternating graded washes of burnt sienna, burnt umber, and alizarin crimson are then painted over most of the wall, leaving the oval highlights unpainted.

2. The darkest wood graining is painted in with burnt umber. The watercolor is applied in very thin vertical strokes using a 000 brush. This very delicate brush must be used in order to capture the fine lines of the graining.

2

3. At this stage, the value of the wood is darkened and the graining is further developed. To accomplish this, a medium-value wash of alizarin crimson and burnt umber is applied in long, thin, tightly spaced vertical strokes. Under this wash the dark veining tends to disappear, so it must be intensified with thin strokes of a dark burnt umber wash.

The wood finish in this example is somewhat shiny; therefore, reflections must be indicated in the wood face. The darkest reflection will be of the dark carpet on the floor. This is indicated by painting in the reflection with a light wash of alizarin crimson. The lightest reflections will be of the stainless steel base and handrail; they are achieved by simply not painting over these areas with the thin alizarin crimson/burnt umber strokes mentioned in the preceding paragraph.

No light reaches the area where the wall meets the ceiling above the highlights. This area is darkened with heavy graded washes of alizarin crimson and burnt umber.

Finally, a thin wash of burnt sienna is painted over the entire surface, to smooth the graining and soften the highlights.

4. The wall on the left side of the elevator cab, as well as the elevation below, are completed in the same manner as in the preceding example. The wall on the left side of the cab is graded slightly darker in the corner to help distinguish it from the wall on the right side. Details such as the thin stainless steel strips are added at the end, using different hues of opaque watercolor loaded into a ruling pen.

1

2

3

PROJECT:
Plaza Las Fuentes
Pasadena, California
ARCHITECT:
Charles Pfister Associates

This example illustrates a drawing with many detailed elements. Such drawings require a great deal of planning. In this instance, the redwood arches and screens were the most difficult elements to draw, not so much because of the graining as in the previous example, but because they had so many small pieces.

1. The largest pieces of the arches are painted in first with burnt umber, burnt sienna, and alizarin crimson. This helps not only to establish the darkest value of the drawing, but also to break up the large ceiling and wall surfaces into smaller, more manageable areas for applying later washes. Because of the complexity of the chandeliers, great care must be taken when painting the arches to avoid painting over a light fixture. Note that the graining on the arch in the foreground is more prominent than that in the middle ground. Graining is not visible at all in the background arch.

2. After the walls and ceiling are painted in, the latticework screens are added to the background and middle-ground arches. These could not have been put in before the wall and ceiling washes, as painting over them would have caused them to smear, and painting in between them would have been painstakingly slow. Because the screens overlap dark as well as light areas, they must be rendered with opaque water-color. The color used is burnt sienna mixed with Chinese white, and it is applied with a ruling pen.

3. The wooden screen on the wall is painted in the same manner as the wooden arches. However, because of the simplicity of the surface behind the screen (a mirror), it is not necessary to use opaque watercolor. For simplicity's sake, the faces of the latticework members are painted darker than the sides, although in reality the values would probably be reversed.

4 (overleaf). The completed drawing shows how the attention paid to each element contributes to a finished look.

4

PROJECT:
**USAA Home Office Building
Expansion
San Antonio, Texas**
ARCHITECT:
The Whitney Group, Inc.

One important feature of this drawing is the wooden louvers. To paint them, a light wash of burnt sienna is first put down over the entire area. Next, each louver is painted with a wash of alizarin crimson mixed with burnt umber. Finally, the bottom edge of each louver is painted using a straightedge and a brush, using a darker mixture of the alizarin/burnt umber wash.

PROJECT:
A House in the Woods
Hammond, Louisiana
ARCHITECT:
Stephan Hoffpauir

ILLUSTRATIONS

7. ELEVATIONS

ELEVATIONS ARE drawings depicting the vertical planes of buildings. Because they are easily projected from plans and can be drawn quickly, they provide architects with a very valuable means for studying building façades. They are far easier to execute than perspective drawings, but have the disadvantage of being inherently two-dimensional. Therefore, the sense of solidity and the perception that walls are receding or advancing, which in nature is the result of perspective effect, must be achieved in elevations solely via the use of shadows. In an elevation, the relative distance between two walls is established by the extent of shadow the first wall casts on the second.

In creating an elevation in watercolor, crucial to the success of the final product is the technique used to render glass. It was previously mentioned that shadows are not cast on glass. This is a phenomenon that you must generally ignore when depicting glass in an elevation. Today it is not uncommon for the major part of a building's surfaces to be comprised of

glass. In most instances, to neglect to cast shadows over windows would seriously undermine the legibility of a rendered elevation.

Glass is unlike any other building material, and failing to treat it as a special material in a drawing will confuse viewers as to which areas are glass and which are not. Even in an elevation, the shimmering, reflective quality of glass must be suggested. Fortunately, this quality is easily achieved with the use of graded washes. In an elevation drawing of a low-rise building, a window is graded dark at the bottom and light at the top, or vice versa, depending on the artist's preference and the requirements of the drawing. This technique is repeated for every window in the elevation. In a high-rise building a slightly different approach is necessary. Each piece of glass will be assigned a single color value with no grading. However, as you move upward, each row of windows will possess a stronger value than the row below it, and the glass over the entire face of the building will grade from light at the bottom to dark at the top.

Whether you are depicting a low-rise or a high-rise building, it is usually best to mask the windows with drafting tape and then paint the spandrels, columns, and all other solid, nonglass surfaces. This is especially true when painting high-rise elevations, as it is far easier to cover the opaque surfaces of a building with a single broad wash than to try to paint around each individual window. It is also easier to grade solid wall surfaces from light to dark. Once that is done, the tape can be removed and the windows can be painted individually.

HIGH-RISE BUILDINGS

High-rise elevation drawings provide a convenient tool for studying the façades of buildings. In these drawings, glass is very important and makes up a large part of them. A high-rise structure may be taken out of context and drawn as an isolated object, or it may be shown in its proper relationship to surrounding buildings.

PROJECT:
191 Peachtree Tower
Atlanta, Georgia
ARCHITECT:
John Burgee Architects

This drawing had to be completed in a relatively short period of time; it could not be rendered quite as fully as others we have done. In certain areas, notably the lower floors of the tower, washes either were not applied, or were applied very lightly letting the pencil lines show through and thereby saving time. Because the stone color was so much lighter than that of the windows, we were able to paint a wash over the entire face of the building and then paint the windows on top of that wash. This eliminated the time-consuming process of cutting a mask for every window. Where the glass was dark enough, mullions were drawn on with Chinese white.

This drawing is a good representative of the way glass on the surface of a high-rise building grades from light on the lower floors to darker on the upper floors. It illustrates how glass reflects the sky, which appears lightest at the horizon and gradually increases in value and color intensity as it moves upward. For the sake of consistency, the glass on the low-rise portion in front was graded in the same way.

In an elevation in which one wall is in the background, one is in the foreground, and there is no shadow, you can indicate the relative positions of the walls by grading the background wall lighter at the bottom. This technique is used here, where the face of the tower slips behind the face of the low-rise building. This technique is also particularly noticeable where the uppermost element crowns the top of the building.

Because of the extreme narrowness of this elevation, a light coat of pastel was applied to the bottom background portion of the drawing. This helped to fill out the white space, and gave the light bottom portion of the tower an area against which to contrast.

PROJECT:
Tower 800
Houston, Texas
ARCHITECT:
**Gensler & Associates/
Architects, Houston**

Here is a design for an unbuilt high-rise and the existing buildings surrounding it. The proposed office tower is the pink stone building in the right half of the drawing. Of equal importance to the composition is the building with the rather ornate top in the left half of the drawing. This building is located across the street from the site of the proposed building. It is a locally historic skyscraper, built in the 1920s. Because of its recognizability in the city's skyline, it is included in the drawing as a sort of signpost, specifying the location of the new building.

This drawing is a good example of the different techniques used to render clear glass and reflective glass in elevation. In the building on the right, the stone is lighter at the bottom and darker at the top, whereas the glass is darker at the bottom and lighter at the top. This is a reversal of the customary way in which reflective glass is depicted in a high-rise building. Usually, the glass is darker at the top of the building to reflect the deeper values of the upper reaches of the sky. In this case, however, we did not want the entire background to be composed of sky. Here the sky is graded at the bottom of the drawing, and the windows at the bottom are darker to reflect this. To paint the building, we first masked each window with drafting tape. After the stone

TOWER 800

was rendered with several graded washes, the tape was removed and the windows were painted individually. Some of the windows, particularly those of the lower floors, received quite a number of washes. In doing a drawing of this sort, care must be taken to ensure that there are no abrupt changes in value in going from one row of windows to another. Although shadows are not cast on glass surfaces, they were added here in order to illustrate that the face of the glass is recessed from the face of the stone.

The glass of the building on the left is clear. It is depicted as though a shade behind each window has been pulled halfway. The shadow in each window is actually a shadow cast on the shade. The black area below each shade is simply the space beyond the window. Clear glass without covering behind it usually appears as a black hole. The windows here are rendered as they have been to create the illusion that one is looking through the glass to the space behind. Because the solid areas of the elevation are made up—not of a single material— but rather of spandrels and piers that could be painted individually in stages, masking the windows was not necessary.

The other buildings in the drawings are background buildings. They were added to signify to the viewer that the project is to be located in a dense urban environment. To give them the same intensity as the foreground buildings would be to create a distraction, however. Instead, they are drawn with lighter washes and less detail, as though one is looking at them through a haze.

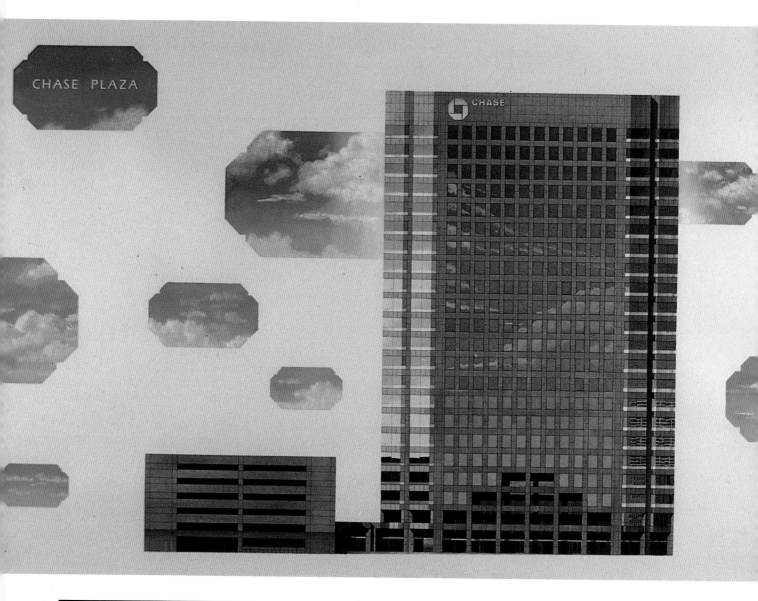

CHASE PLAZA

PROJECT:
Chase Plaza
Los Angeles, California
ARCHITECT:
Gensler & Associates
Architects, Houston

As has been previously stated, reflective glass *reflects* its surroundings. If there are clouds in the sky, clouds will appear in the glass. In this example, the glass is rendered in the manner typical for high-rise buildings, but, unlike the previous examples, cloud reflections were painted onto the glass. This technique yields dramatic results, and is simple to execute.

First, outlines of the clouds are drawn over the face of the building with a soft graphite pencil. Where these outlines overlap the windows, the clouds are painted with Chinese white and graded as necessary. Note that the clouds end where the glass changes plane and do not turn the corner and wrap around the building like wrapping paper. On the lighter left-hand side of the building, clouds are suggested by simply leaving some of the white paper unpainted.

You will also notice that some of the surrounding buildings are reflected in the glass. On the left side of the tower, a reflection of the garage can be seen, and on the right side you will see reflections of the buildings across the street. Glass typically creates warped or distorted reflections. This was taken into account in depicting the reflections here.

The shapes of the pieces of sky floating about the drawing were derived from the shape of a typical floor plan. The clouds were created by dabbing Chinese white over a Prussian blue background with a sea sponge.

122

LOW-RISE BUILDINGS

Low-rise elevation drawings, like high-rise elevation drawings, provide a relatively quick and easy method for studying the proportions, massing, and materials of buildings. A low-rise building is typically drawn as an isolated object, with or without a background.

PROJECT:
Columbia Savings
Los Angeles, California
ARCHITECT:
Skidmore, Owings & Merrill

1. Before this drawing is begun, a study is done to allow us and our client to check colors and values.

1

2

3

4

2. Initially the perimeter of the building and all windows are masked with drafting tape, and a smooth, light wash of burnt umber is put down on the front panels of the building.

3. The windows are painted next, with a light wash of thalo green. Several coats of Prussian blue are then graded on top of the thalo green.

4. The shadows on the windows are painted with a wash of Prussian blue and a small amount of thalo green. A purple made of alizarin crimson and ultramarine blue is then graded along the top edge to darken it. The columns are painted with a wash of burnt umber and ultramarine, mixed together to make a neutral gray. A second wash is used to darken the web of the column, and a third wash is used to grade it darker at the bottom. The marble wash is made with Hooker's green and some Prussian blue. (Veining is added later.) The black stone below the green marble at the base of the building is painted with a very dark wash of burnt umber and ultramarine. The stainless steel panels under each window are painted with a light graded wash of ultramarine blue.

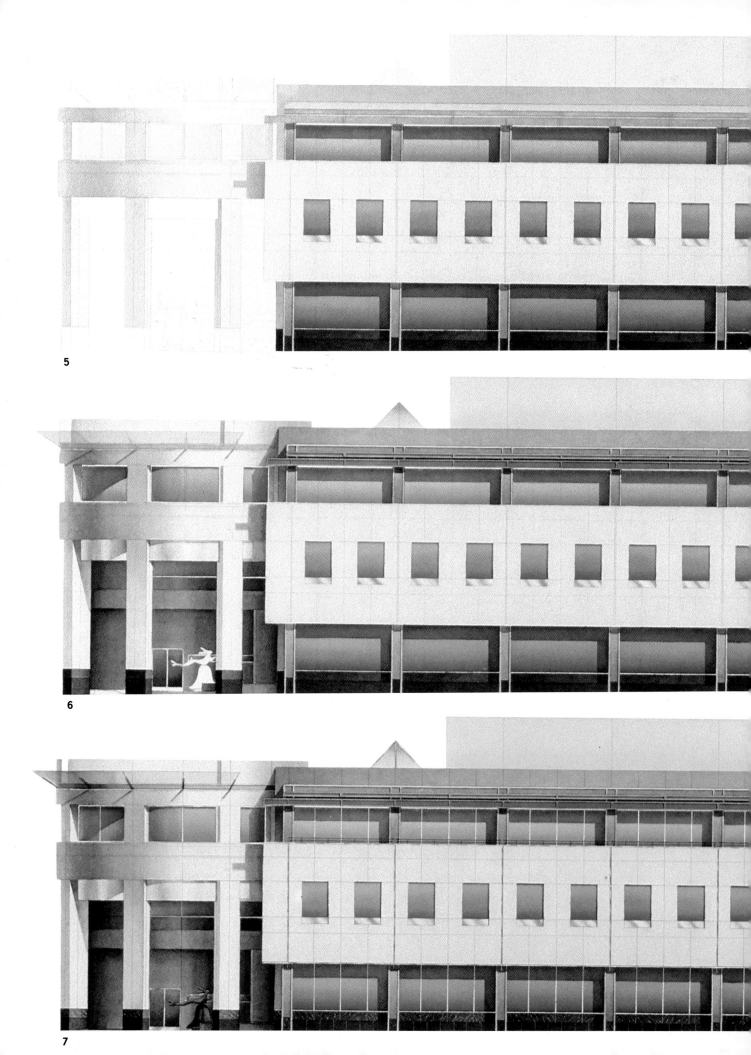

5

6

7

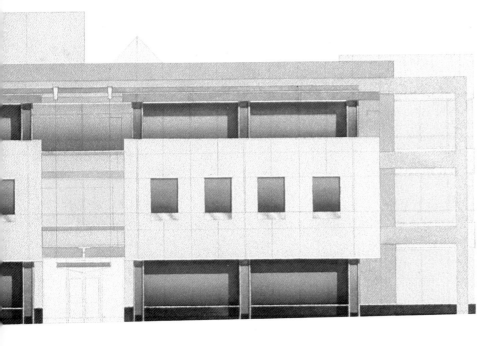

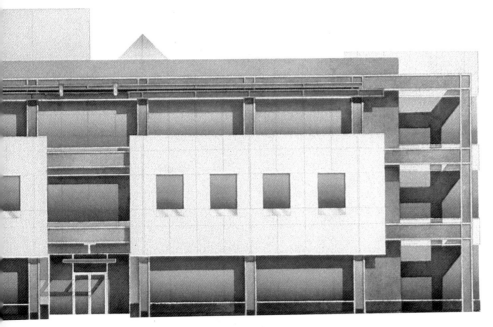

5. The seams and columns are completed. The blue horizontal beams at the top of the building have an undercoat of Prussian blue mixed with a small amount of ultramarine. The darker planes of the building are also painted at this time, with a mixture of burnt umber, alizarin crimson, and ultramarine.

The rotunda is begun by painting its exterior with a light wash of burnt umber graded darker as necessary to define its curved form. The shadow is also painted with burnt umber, but a bit of purple may be added if it appears too brown.

6. The shadows on the darker back planes of the building are rendered with an ultramarine and alizarin purple. After all beams and columns are completed, shadows are added. The pyramid skylights on top are painted first with a light wash of ultramarine and then with a darker wash, graded lighter at the bottom.

The shading on the rotunda is darkened so that the curve becomes more three-dimensional. The rest of the shadows are added with a combination of burnt umber and purple. The windows and their shadows are painted using the same washes that were used on the rest of the windows, and the sunscreen receives a base wash of thalo green. The inside of the rotunda is painted with a mixture of burnt umber, ultramarine, and alizarin crimson. It is darkened and graded with Prussian blue. This helps to neutralize it and prevent it from becoming either too brown or too purple. The stainless steel panels are added with ultramarine washes.

7. Mullions are added to both the main building and the rotunda using Chinese white applied with a ruling pen. The veining in the green marble at the base is achieved carefully scratching some of the pigment away with an X-Acto knife. The sunscreen on the rotunda is darkened and graded with Prussian blue. And finally, the rabbit sculpture is painted in with a mixture of burnt umber, ultramarine, and alizarin crimson.

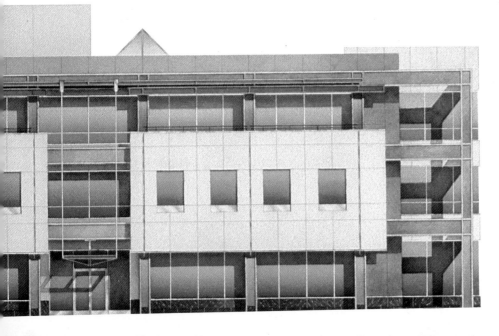

BACKGROUNDS IN ELEVATIONS

It is usually sufficient to leave the background of an elevation unpainted, allowing the colors of the building to stand out vividly against the white of the paper. Sometimes, however, a background can be used to tell the viewer more about a building, or to create a mood.

PROJECT:
A House in the Woods
Hammond, Louisiana
ARCHITECT:
Stephan Hoffpauir

In this project, the location of the building (a house in a densely wooded setting) was an important element in the building's design. For this reason, a background of trees and sky was painted in to engender the aura of a small house sheltered from the world by its natural setting. You will notice that the background recedes, as in a one-point perspective, whereas the house in the foreground is a flat elevation. Setting an elevation within a one-point perspective is a technique that can sometimes be used to give the elevation a greater sense of depth and dimension.

This drawing was inspired by the works of the nineteenth-century German Romantic painter Karl David Friedrich. His paintings of thinly populated landscapes in twilight have an other-worldly, mystical quality. By choosing twilight as the time setting, and by using intense, deep colors for the sky and foliage, we wanted to draw the viewer out of the darkness of the woods and the encroaching night, and into the cozy shelter of the house. You will notice that the shadows on the house have absolutely no relationship to the location of the sun, which presumably has just slipped behind the tops of the trees. This liberty was taken in order that the shadows would retain their typical function—to describe the solidity and mass of the structure.

To paint a sky like the one here, a wash of raw sienna is laid down from the top of the drawing to just below the tree tops, where it is then graded with water. The trees are so dark that, when the place where the raw sienna wash ends is painted over, the bottom edge of the sky is covered by the trees. After this, several graded washes of Prussian blue mixed with alizarin crimson are painted over the upper three-quarters of the sky. To use pure Prussian blue over the raw sienna would turn the sky green; therefore, the alizarin crimson is added to counterbalance this effect.

To depict the foliage, a wash of Hooker's green mixed with Prussian blue and alizarin crimson is painted over the trees and grass. The tree trunks are left unpainted. A second wash of the same mixture is painted over the trees only. To complete the grass, horizontal streaks of alizarin crimson are painted on. To complete the foliage and the leaves of the trees, random, alternating dots of alizarin crimson and a purple made with ultramarine and alizarin crimson are painted on with a small brush. The tree trunks are painted with alternating washes of burnt sienna and the same purple as for the leaves.

A HOUSE IN THE WOODS
FOR
A CARPENTER'S FAMILY

8. PERSPECTIVES

T IS VERY COMMON for architects and designers to use orthogonal drawings—such as plans and elevations—in the early stages of a design project, as both a design and presentation tool. In later stages, however, as the design becomes more resolved, it is customary that there be at least one three-dimensional representation of the project, either in the form of a scale model or a perspective drawing.

Many excellent books giving instruction in perspective drawing have appeared over the past few centuries. Typically, perspective drawings have been laboriously "constructed" by hand according to long-established guidelines, but the increasing use of computers with three-dimension-drawing programs may soon make this practice obsolete. Even with computer-generated perspectives, the human hand is still usually needed to edit out the computer plot's superfluous lines, and to add such items as cars, trees, and people. We shall assume that the reader of this book has the working knowledge necessary to produce a perspective line drawing, whether by hand or with the aid of a computer.

As has been previously stated, watercolor is a fast but unforgiving me-dium. For this reason it is necessary to work out all details of a drawing on tracing paper before the final color drawing is begun. It is customary for architectural illustrators to send preliminary line drawings to clients for review and approval before proceeding with the final drawings. This helps to prevent disappointment on the part of the client and costly and time-consuming redrawing on the part of the illustrator. After a drawing has been completed, it may be impossible to add a person or move a car, for instance.

A perspective line drawing should be done with an H or 2H pencil on good-quality tracing vellum. When the drawing is complete, blueline prints can be made and then used to transfer the drawing onto watercolor paper (see Chapter 4). If you have worked out all compositional details of the drawing by this stage, the watercolor process should go smoothly.

HIGH-RISE BUILDINGS

Rendering a perspective of a high-rise building is different from rendering a perspective of a low-rise building in a few subtle but important ways. First, because a high-rise building is so much larger, the station point will be much further back. As a result, individual elements such as cars and people will be much smaller. These elements will be easier to draw and paint, but this change will be offset somewhat by the fact that there will be more of them.

Another major difference between the two building types is the surrounding environments. Although there are many exceptions, high-rise buildings tend to be in dense, urban settings, whereas low-rise buildings are usually in suburban or rural settings. When you are doing a perspective drawing of a high rise, you must pay more attention to the surrounding buildings, which often must be drawn with as much care as the feature building.

Finally, these two building types differ in the way glass appears. In a high-rise building the amount of glass surface reflecting the sky is proportionally much larger. You recreate the sky reflections in a high-rise perspective in the same way as you would in a high-rise elevation. The value of the sky reflection is lighter for the lower stories, increasing gradually as the reflection moves toward the top stories.

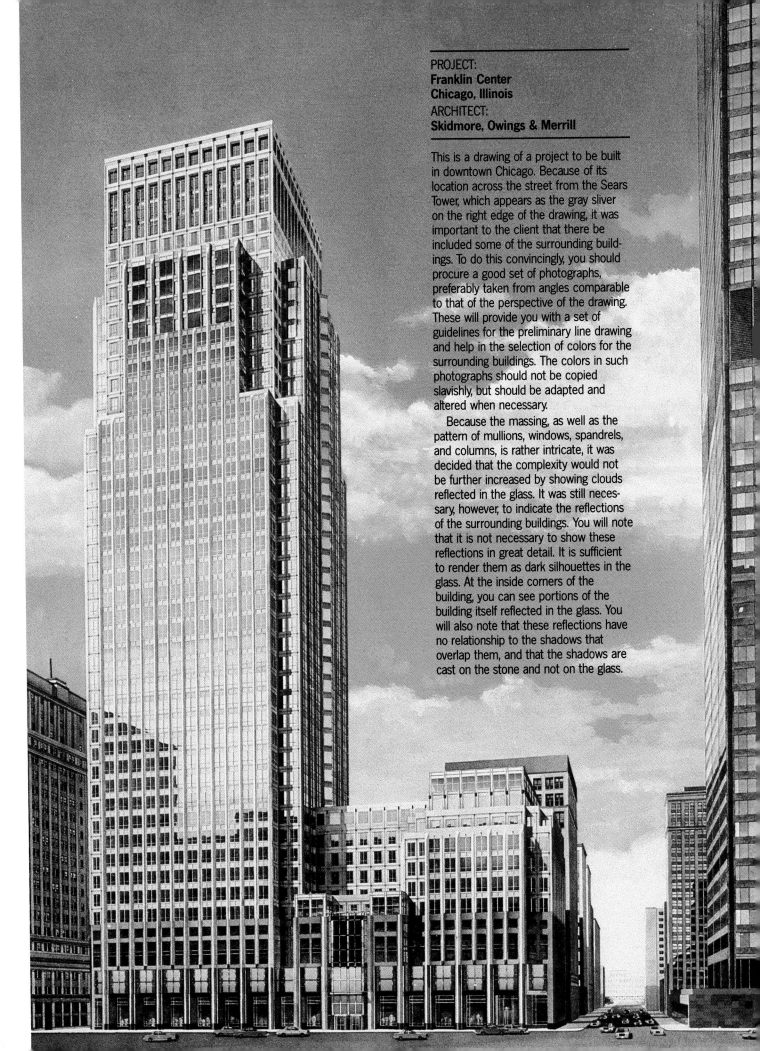

PROJECT:
**Franklin Center
Chicago, Illinois**
ARCHITECT:
Skidmore, Owings & Merrill

This is a drawing of a project to be built in downtown Chicago. Because of its location across the street from the Sears Tower, which appears as the gray sliver on the right edge of the drawing, it was important to the client that there be included some of the surrounding buildings. To do this convincingly, you should procure a good set of photographs, preferably taken from angles comparable to that of the perspective of the drawing. These will provide you with a set of guidelines for the preliminary line drawing and help in the selection of colors for the surrounding buildings. The colors in such photographs should not be copied slavishly, but should be adapted and altered when necessary.

Because the massing, as well as the pattern of mullions, windows, spandrels, and columns, is rather intricate, it was decided that the complexity would not be further increased by showing clouds reflected in the glass. It was still necessary, however, to indicate the reflections of the surrounding buildings. You will note that it is not necessary to show these reflections in great detail. It is sufficient to render them as dark silhouettes in the glass. At the inside corners of the building, you can see portions of the building itself reflected in the glass. You will also note that these reflections have no relationship to the shadows that overlap them, and that the shadows are cast on the stone and not on the glass.

LOW-RISE BUILDINGS

In exterior perspective drawings of low-rise buildings, peripheral elements such as trees become more important. They are larger in these drawings than in drawings of high rises, and thus more prominent. It is even more important for low-rise drawings that peripheral elements be drawn and painted skillfully.

This added difficulty, however, is offset by the fact that it is usually quite easy to depict the surrounding environment of a low-rise building. As the drawing is usually going to be cropped rather closely to the building image, it will be sufficient to give just a suggestion of a surrounding area. The surrounding environment will often consist of little more than some dense foliage.

1

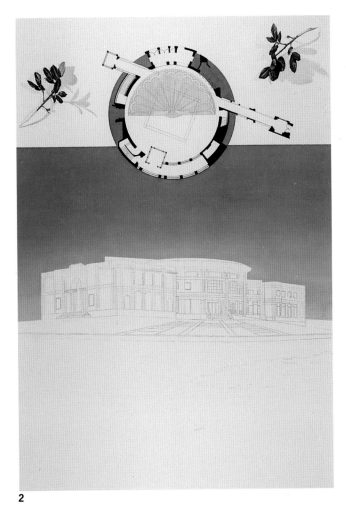

2

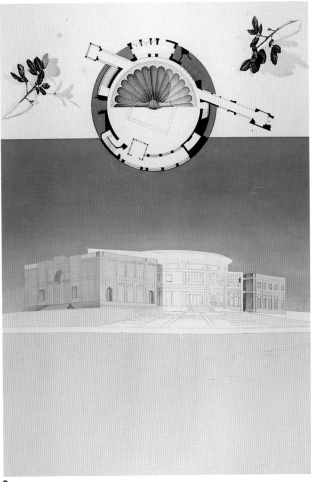

3

This drawing was commissioned as a promotional piece, to raise funds for the museum's new addition. For this reason, the client wanted something "special," and we were able to embellish the drawing with elements that relate thematically to the project. Because the plan of the central rotunda is interesting graphically, we used it as the central element of the drawing. The shell in the center of this plan is one of the stone details found in the original museum building, and the oak leaves on either side of the plan are a reference to the parklike setting the museum will have. The large area of grass at the bottom of the drawing was intended to be background for a title.

1. Several studies showing various compositions are done, and after one is selected, a complete line drawing is done. The line drawing is then transferred onto the watercolor paper. Several branches of oak leaves are photographed, to provide a guide for both the line drawing and the painting. The leaves are painted predominantly with a combination of Hooker's green mixed with a very small amount of alizarin crimson, as necessary. Prussian blue is either added to the Hooker's green or used alone in the shaded and shadow areas.

2. After the branches are completed, the circular plan is inked so that the sky can be put in. The edge of the building is masked with drafting tape, as is the perimeter of the area to be washed. The sky wash is Antwerp blue. First, a flat, light wash is put down with darker washes graded over it, leaving it darker and more intense at the top. It is left light at the border next to the building in order that the building and sky contrast.

Next, a light wash of Winsor & Newton's burnt umber is put down over the entire shell.

3. After this initial wash, the darker areas are shaded with a mixture of burnt umber and alizarin crimson. The shadow is done with alternating washes of burnt umber mixed with alizarin crimson, and an ultramarine/alizarin purple.

Also at this time, a smooth, light wash of raw sienna is put over all areas to be grass.

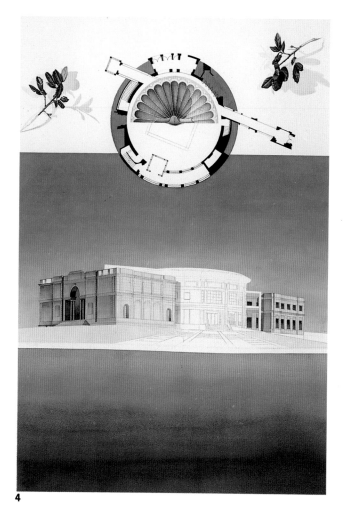

4

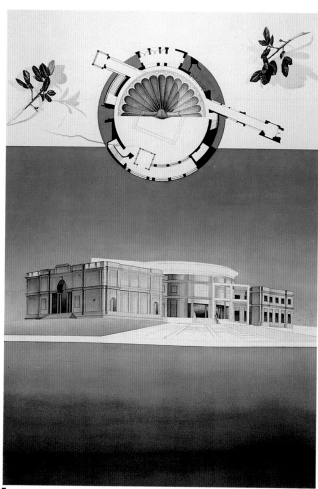

5

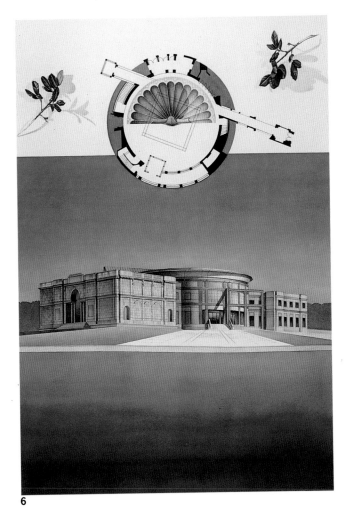

6

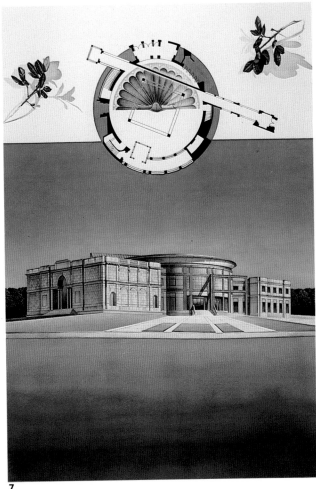

7

4. After all elements at the top of the drawing have been completed, the building is worked on. The two end sections of the building are limestone and the central drum is stucco. First, a light wash of Prussian blue mixed with alizarin crimson is put on the two end sections. (For purposes of this discussion, this mixture will be called Prussian purple.) Next, the areas in shadow are added with a darker Prussian blue and graded with a mixture of ultramarine and alizarin crimson. The windows on the right side of the building are done with a flat wash of dark Prussian purple and then graded with an even darker wash of the same color. The same is done on the entry at the left side of the building.

5. Next, the central drum portion of the building is done. The mass of the drum is painted with a wash of burnt sienna and graded with a Prussian purple, as are the windows on the ground level. All grading is done with either burnt sienna, with a bit of alizarin crimson in some areas, or with Prussian purple.

6. The drum is completed by darkening and intensifying certain areas with the colors mentioned in the preceding description, as well as by adding shadows. The banner wall at the front is painted with a mixture of Prussian blue and Hooker's green, while the shadows are done with straight Prussian blue.

The skylight at the upper left side of the building is also painted with a mixture of Hooker's green and Prussian blue. The darker side is graded with Prussian blue.

The grass is also completed at this stage. After an initial wash of raw sienna, the grass is graded with Hooker's green. Many coats of green are graded; some of these washes have alizarin crimson added to them. The darkest washes also have some Prussian blue added to the Hooker's green. All shadows on the grass are done with Prussian blue.

7. To complete the drawing, the road and all paved areas are lightly washed with Winsor & Newton's burnt umber. The ends of the road are then graded with burnt umber mixed with alizarin crimson.

8 (overleaf). This shows a detail of the finished drawing.

135

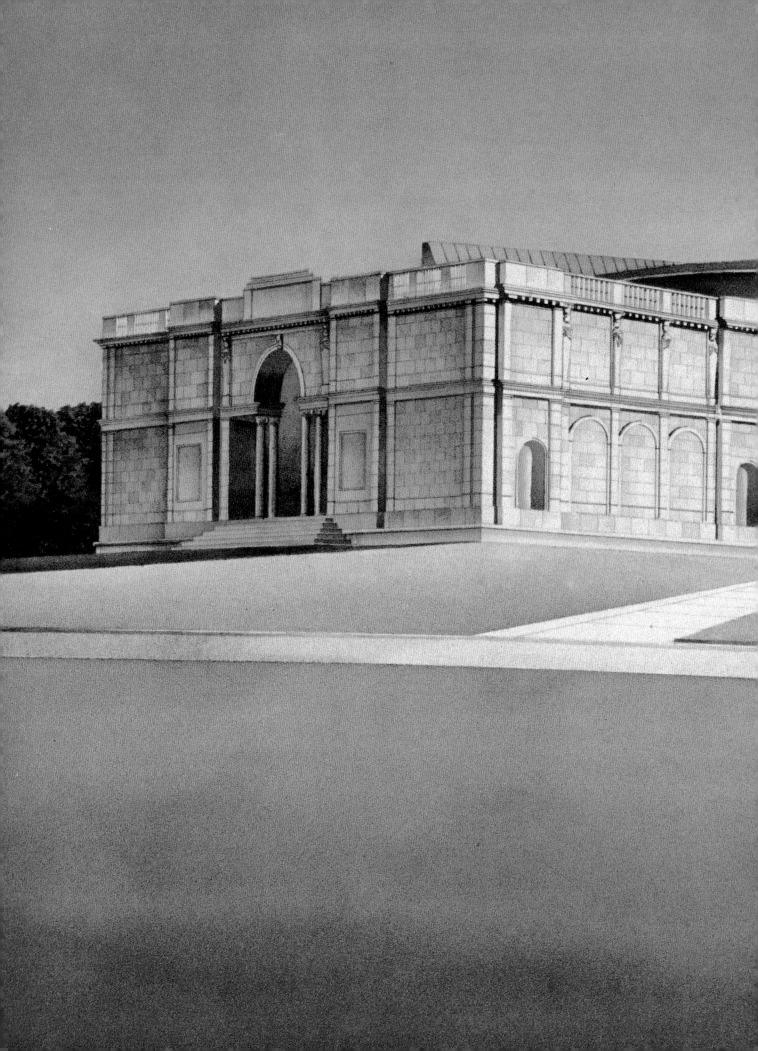

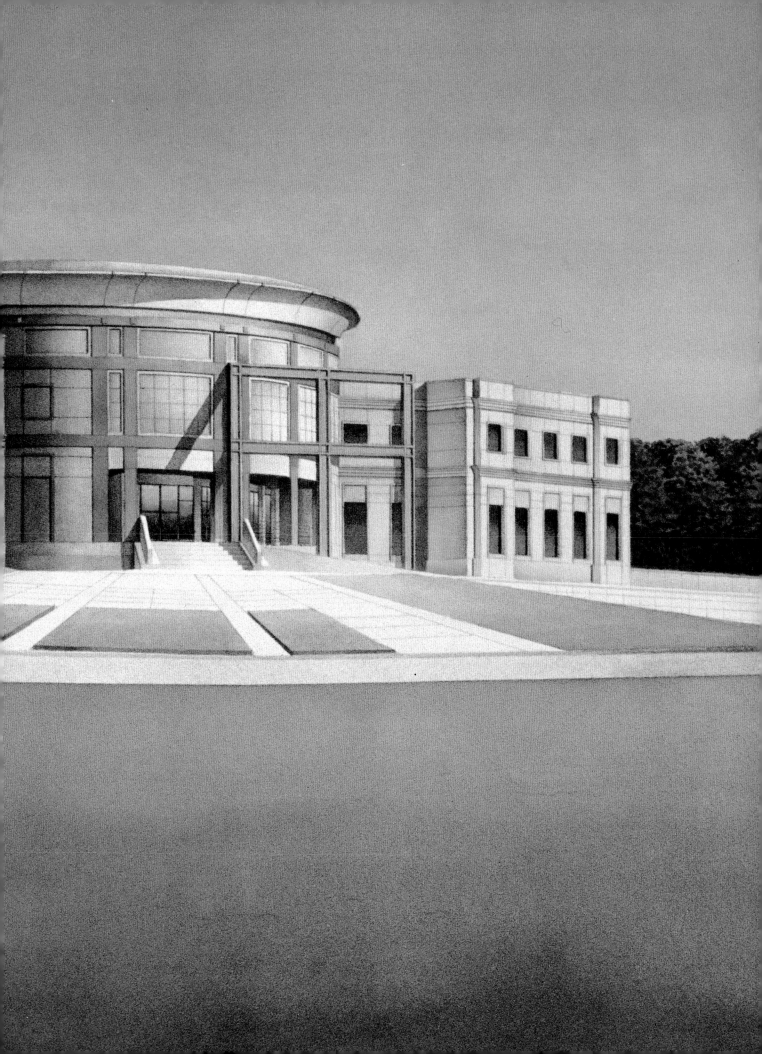

INTERIOR PERSPECTIVES

Beyond the obvious differences, drawings of interiors differ from drawings of exteriors in the way light and shadow are depicted. Look at photographs in an interior design magazine and you will probably notice that there are no shadows in these photographs. If there are, they are apt to have much softer edges than their counterparts in photos of building exteriors. This is because, in an interior, there are multiple light sources—unlike the exterior situation where there is a single light source. This difference is further accentuated by the fact that lamps and ceiling fixtures usually have shades or diffusers covering them, creating softer lighting conditions. The overall effect in interiors is that the various wall and ceiling planes grade from dark to light based on their proximity to a particular light source. You can observe a similar phenomenon outside on a cloudy day. You will not see shadows, but will see a series of darker or lighter wall planes. In this case the clouds are acting as nature's own lampshade. In an interior, you actually *see* the light source. This affects perception of color in a room.

In an exterior drawing, if you were depicting a white stucco house, for example, you would simply let the white of the paper serve as the white, sunlit wall planes. However, in an interior drawing, if you were depicting a white ceiling with lay-in fluorescent light fixtures, you would not be able to leave the ceiling as an unpainted white surface. If you did, you would not be able to distinguish between light fixture and ceiling. If you were to look at such a ceiling in reality, you would see that the color of the ceiling relative to that of the light fixture was a medium-value gray.

In an interior space, colors are perceived differently from the way they are outside; one makes unconscious adjustments when observing the colors of surfaces or objects. In the example mentioned in the preceding paragraph, for instance, you perceive that the true color of the ceiling is white even though, next to the light fixture, it appears gray. Colors inside will generally appear darker and grayer than they appear outside.

When we are about to begin one of our own interior drawings, we will look at a carpet sample in the optimum indoor-lighting situation of our studio. We then prepare a wash that will equal in value, or be slightly lighter than, the piece of carpet. The wash is then applied over the entire carpeted area in the drawing. This will serve as the lightest value belonging to the carpet, and will correspond to the area directly beneath an overhead light. We then darken the carpet in areas furthest away from the light source, such as the far corners of the room. Similarly, wall surfaces adjacent to the darkest parts of the floor will be painted a value darker than the value a sample of that wall would have in optimum lighting conditions. The trick is to maintain a balance between light areas and dark areas, so that the space does not appear gloomy and so that the values of different materials appear to be in harmony with one another.

In one way, an interior drawing is easier to execute than an exterior drawing. You need not worry about depicting shadows in an interior drawing, as one light source in a room is apt to obliterate the shadows another light source is creating. Freed from worries about shadows, you can create a three-dimensional feeling by simply making sure that one set of planes sufficiently contrasts with adjoining perpendicular planes. In other ways, an interior drawing can be more difficult. Wall values inside will be in contrast far less than wall values outside. The strong sense of shade and shadow in contrast to brightly lit surfaces helps to engender dynamism and authenticity in exterior drawings. The inability to take advantage of this when drawing an interior can lead to inert and lifeless drawings. For this reason, it is important to understand the subtle ways in which artificial light defines interior space and creates its own set of opportunities.

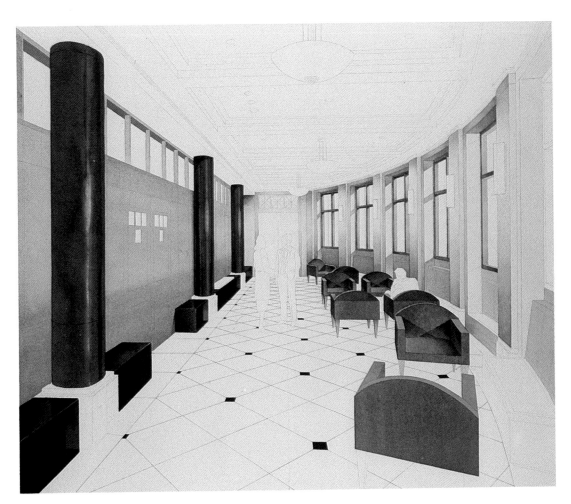

Lobby Interior

PROJECT:
**Harvard Medical School, Building C
Cambridge, Massachusetts**
ARCHITECT:
Tsoi/Kobus & Associates

Before this drawing was begun, a study was done of a small area for the client's approval. This area included all major materials and colors to be depicted.

1. The curved wall is put down first, as this wall establishes some of the lightest values of the drawing. The wall is first painted with a very light wash of burnt umber. A small amount of ultramarine blue is then added to this wash. The

darker surfaces, as well as the graded areas at the top and bottom of the wall, are a mixture of burnt umber, alizarin crimson, and ultramarine blue. The shadows are the same color, with some burnt umber graded at the edges. Where the shadows look too brown, an alizarin crimson and ultramarine purple is added.

The light surface of each window frame is done with a mixture of Hooker's green, Prussian blue, and the slightest bit of alizarin crimson. The alizarin crimson tends to make the color grayer, so just the smallest amount is used. Any shadows falling on the window frames are done in pure Prussian blue. The chairs are first washed with a light coat of

Prussian blue mixed with a small amount of Hooker's green, as shown on the chair in the foreground. Varying values of this color are used on the darker surfaces of the chairs. However, pure Prussian blue is used on the darkest surfaces—surfaces that are in shadows or in dark areas. This is shown on the chairs in the background.

The wood panels below the windows are washed with a mixture of burnt umber, raw umber, burnt sienna, and raw sienna. Two coats of the wash are used on the darker, inward-facing surfaces, while the horizontal surfaces hit by light from the windows are left with only one coat. The few background panels are darkened with graded washes of purple.

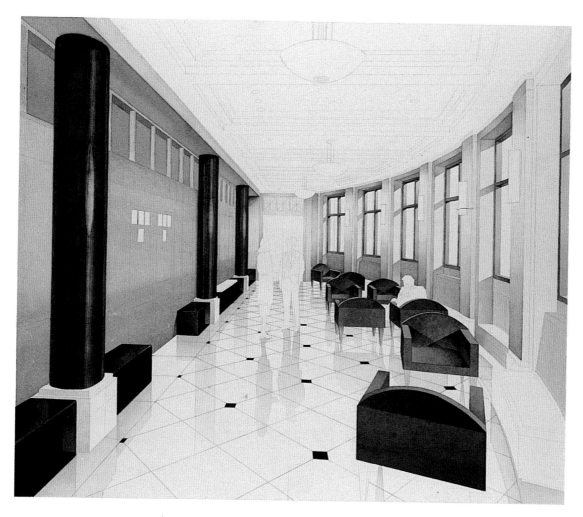

2. The red for the columns is made of alizarin crimson mixed with small amounts of burnt umber and Prussian blue. Shadows on the columns are painted on with a very dark purple made of Prussian blue and alizarin crimson, as seen on the columns in the background. This color is so thick that it appears to be black in most instances. The dark benches are painted first with a wash of Prussian blue and then with graded washes of the blackish purple. The wooden door and panelling are painted with graded washes of the same colors used for the wood panels of the opposite wall. The two foreground chairs are further developed with the same washes used on the background chairs: a mixture of Prussian blue with a small amount of Hooker's green.

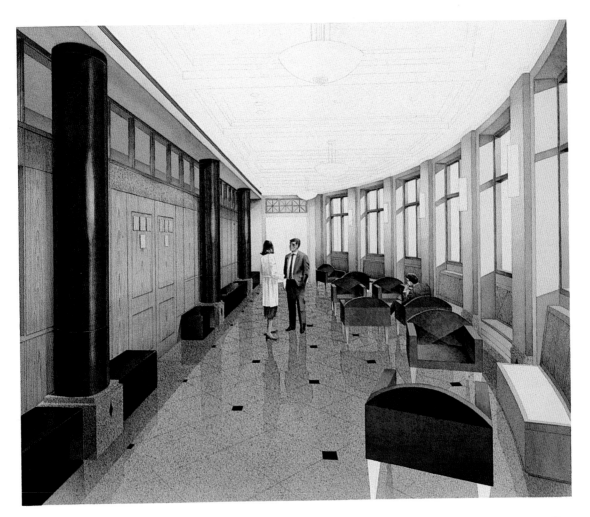

3. The column in the foreground is completed in the same way as those in the background. The soffit above the columns is washed with a mixture of raw umber and alizarin crimson. The edge of the soffit is darkened with a graded wash of Prussian/alizarin purple. Joint lines in the floor are drawn with a ruling pen filled with ultramarine. The back of the foreground chair is darkened with a wash of pure Prussian, as are all the darker areas of the chairs. Reflections on the floor as well as shadows on the plan are added using graded washes of purple composed of ultramarine blue and alizarin crimson.

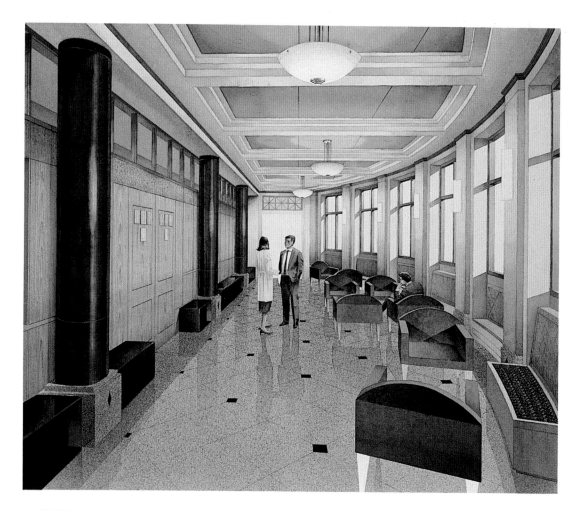

4. The edge of the soffit on the other side of the clerestory openings in the wood-panelled wall is indicated by painting the ceiling beyond with ultramarine. Before the wood grain is painted in, the top of the wood-panelled wall is painted with graded washes. Similarly, shadows created by the columns are painted onto the wall. All wood surfaces in the room are washed with a coat of raw sienna, to give the wood a more luminous character. The backs of the wooden benches are selectively darkened with graded washes of purple. Joint lines on all wood surfaces are drawn with the dark Prus-sian/alizarin purple. The wood grain is painted in a combination of burnt sienna and burnt umber, using a very fine brush and short, vertical strokes.

The floor is to be composed of two types of terrazzo, one for the central portion and another for the border and column bases. In order to render ter-razzo, you must speckle the appropriate area, using a variety of colors and a toothbrush. When speckling with a tooth-brush, all areas not to be painted should be masked off with a frisket film. (This can be purchased in any art supply store.) First, the entire floor, both in the perspective drawing and in the plan below it, is speckled primarily with burnt umber and ultramarine, in alternating fashion, depending on how cool or how warm the color needs to be. Alizarin crimson is also used to speckle, but only a very small amount, as the client wanted this terrazzo portion of the floor to be fairly neutral.

After this base color is painted, the main part of the floor is masked off, leaving only the border and the column bases uncovered. These are then speckled with more alizarin and ultra-marine, to give a more purplish cast.

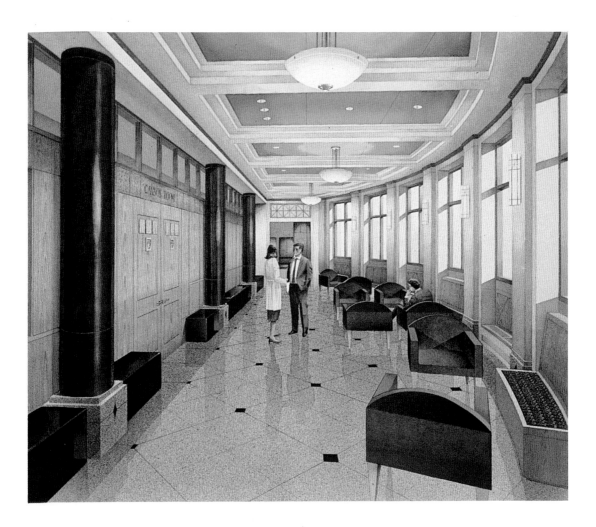

5. The chairs in the plan below are rendered with the same washes as those used in the preceding perspective. Pure Prussian blue is used once again to indicate the dark shadows falling across the chairs themselves. The wood panels are also done with the same wash as that used for wood panels previously— burnt umber, raw umber, burnt sienna, and raw sienna. An alizarin crimson and ultramarine purple mix is used for the shadows on the wood. The window sills (and their shadows) are done in the same way as those in the perspective.

9. BUILDINGS AT NIGHT

THERE IS perhaps no type of architectural drawing more striking than a night drawing. Given the heightened sense of drama, you might come to the conclusion that such a drawing is more difficult to execute than a day drawing. The fact is that, provided you are familiar with the genre's basic conventions, a building at nighttime is usually much easier to reproduce than a building during the day. In order to achieve the nighttime effect, it is necessary to comprehend the elements that make a nighttime drawing different from a daytime drawing. The two types differ in four aspects: light, color, contrast, and detail.

Although it may seem obvious, it is necessary to note that it is the nature of the light that establishes the difference between daytime and nighttime. During the day a single, overhead, natural light source—the sun—throws a uniform light over the surfaces of buildings, and shadows on vertical surfaces are cast downward. A building at night is usually illuminated by multiple artificial light sources, and these originate from horizontal planes below the top of the building. As a result, shadows on vertical planes are cast upward and shadows on horizontal surfaces are nonexistent. Many examples of this phenomenon can be seen in the work of Hugh Ferriss, the great 1930s delineator of high-rise buildings.

Light determines not only the perception of form, but of color as well. Most people are quite used to looking at buildings or objects by daylight, but are less familiar with those same buildings or objects at night. They are aware that a building's color is darker at night, but are surprised to find that the nighttime color, more often than not, bears little resemblance to the daytime color. This is particularly true in nighttime photography. It is also interesting to note that good nighttime photographs will record a rainbow of deep colors that, under normal nighttime observation, would appear to be little more than shades of gray and black.

Without the intensity of daytime illumination, contrasts between the different intersecting vertical planes of a building will be reduced, as will the contrasts between building materials. As a result, one's ability to perceive detail will be diminished. Having less contrast and detail, a building at night becomes easier to delineate.

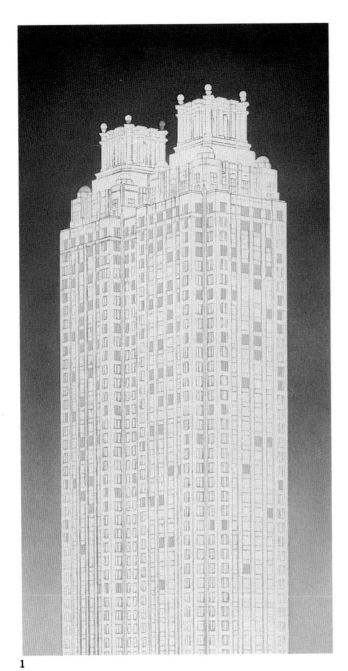

1

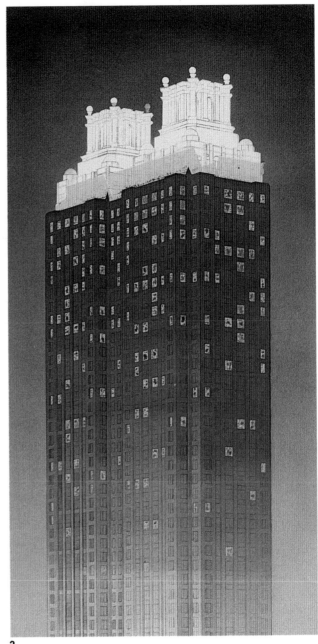

2

High-Rise Building

PROJECT:
191 Peachtree Tower
Atlanta, Georgia
ARCHITECT:
John Burgee Architects

The illustrations of the high-rise building that follow are good representatives of the phenomena just discussed. There are three principle light sources in this drawing. Light from the unseen base of the building fades away, leaving the upper portion of the shaft in darkness. Light from inside the building illuminates the occasional window, but has no other effect on the exterior of the building.

Finally, a ring of lights at the roof level illuminates the twin tops. The color scheme for the drawing was derived from a twilight photograph of a high-rise building not unlike the one shown here. At no time was gray or black used in the drawing, as their use would have resulted in a muddy color scheme. Gray and black should be reserved only for night-time drawings done in black and white.

1. The first illustration shows the completed sky. The edges of the building are masked off with masking tape, and a wash of alizarin crimson mixed with a little raw umber is painted over the sky area. Two different blue pastels are applied over most of this base color, and

then smoothed out with a paper towel to produce a uniform graded tone. This step could be done in watercolor, but given the large, unbroken area of deep blue, it would be difficult to do this without streaking. After the pastel sky is sprayed with fixative, the masking tape is removed, and new masking tape laid over windows to be illuminated.

2. After the edge where the bulk of the building meets the tops is masked, a uniform wash of raw sienna is laid over the entire building shaft. Graded washes of purple made of ultramarine and alizarin crimson are painted over the raw sienna. A final wash of the same purple is applied to the dark sides of the building.

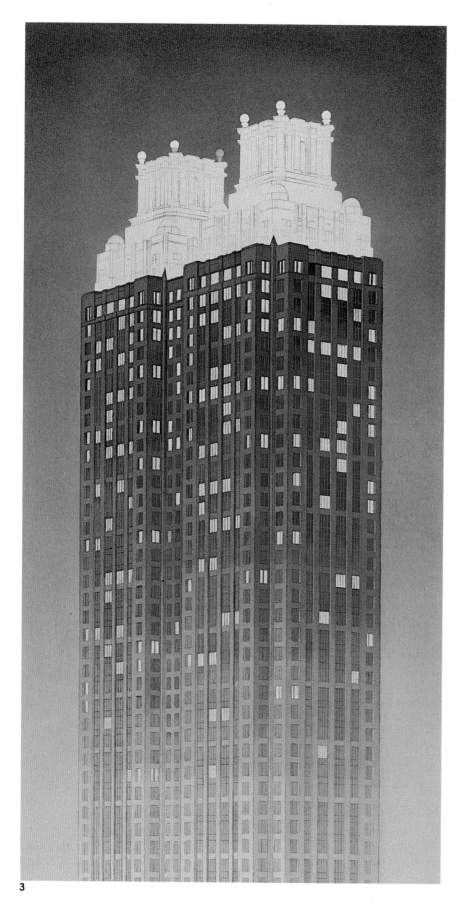

3. The nonilluminated windows are painted with the same purple wash in the lightest areas and a darker ultramarine in the dark areas. The uppermost windows are painted with a dark Prussian blue. The masking tape is removed and the illuminated windows are painted with raw sienna. Dark lines and details are drawn in purple with a ruling pen. Light lines are drawn using a white pencil. The building tops are begun, using a light wash of raw sienna.

4. The stone walls and columns of the tops are completed with alternating, graded washes of purple composed of ultramarine blue and alizarin crimson, burnt sienna, and alizarin crimson. The windows are painted with graded washes of Antwerp blue. The small domes and balls are painted, first with ultramarine blue, and the dark areas are then added with a mixture of Prussian blue and alizarin crimson.

3

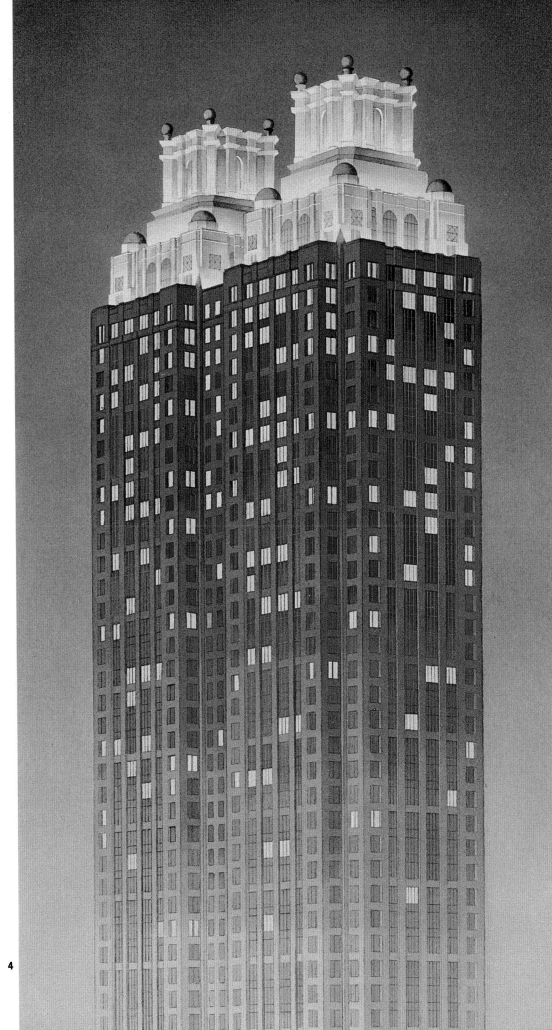

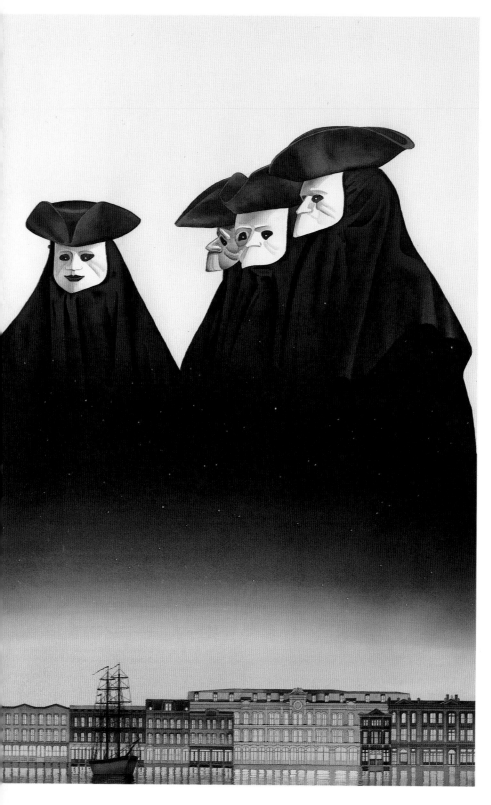

Low-Rise Building

PROJECT:
**Commemorative poster
"Carnival of Venice"**

Rather than being the focus of a drawing, buildings are occasionally nothing more than details within the larger composition. In this illustration, for example, the building elevations occupy less than one-seventh of the overall area. Above them, the sky darkens to become, in the uppermost reaches, silhouettes of four brooding, masked figures that dwarf the scene below.

This drawing was used as a poster design to commemorate the 1988 Mardi Gras celebrations in Galveston, Texas, whose theme in that particular year was "Carnival of Venice." The masks and costumes worn by the four revelers are traditional, eighteenth-century, Venetian carnival attire. This particular theme had been chosen because both Galveston and Venice are island cities with carnival traditions, although Galveston's observance of Mardi Gras has only recently been revived. Galveston was a prosperous port city in the nineteenth century, and, as a result, has a large stock of historic buildings from that era. Several of the city's historic mercantile buildings are depicted here, not in their actual locations relative to one another, but rearranged like pallazzi along an imaginary Grand Canal.

The aim in depicting these buildings at night was to create a scene that would be mysterious, elegant, and seductive. Given the somewhat somber, austere appearance of the masked figures in the nighttime setting, care had to be taken to ensure that the atmosphere would not in any way be one of gloom. In order to execute a drawing like this successfully, gray and black, or any combinations of colors that would produce them, must be banished from the palette.

To create a drawing having the detail shown here, a wash of raw sienna is first applied over the buildings and the bottom portion of the sky. This color creates

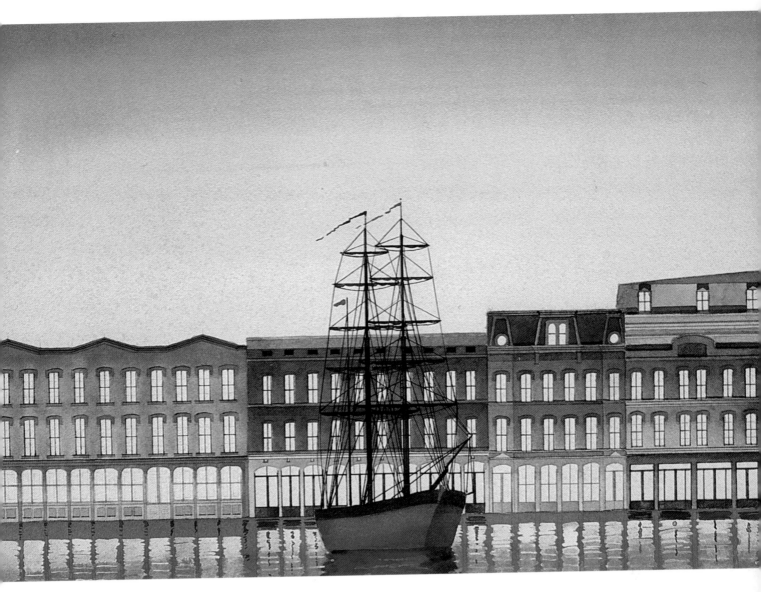

the yellow of the illuminated windows and the bright glow behind the buildings.

Graded washes of Prussian blue mixed with alizarin crimson are painted over the upper portions of the sky. When applying any blue over raw sienna, you must mix some alizarin crimson into the blue wash in order that the raw sienna and the blue do not combine to produce green. For the same reason, a purple wash made of ultramarine blue and alizarin crimson is painted over the solid areas of the building facades. Purple and yellow are color complements and tend to neutralize each other. Similarly, the red brick surfaces are painted with washes of alizarin crimson mixed with a little ultramarine blue. The blue prevents the alizarin crimson and raw sienna from becoming too orange. Pure blue may then be applied over the purple washes without becoming green.

The building facades are depicted as though they are illuminated from an unseen light source at their base. To achieve this effect, the building faces are darkened at the upper floors with graded purple washes. This renders the buildings lighter at the base where the light source is located, and darker at the top where the light falls away.

The water, which has been left unpainted up to this point, receives a wash of pure Prussian blue, which forms the base color. Dark reflections are added by painting on with more Prussian blue. Light reflections are painted on with an opaque mixture of raw sienna and Chinese white.

10. DRAWINGS FROM PHOTOGRAPHS

WHEN THE well-known photorealist painter Ralph Goings was asked why he felt the need to produce a painting of a perfectly legible photograph, he answered, "If you stopped with the photograph, what you would have is a photograph, and what I want is a painting." Present-day topographical painters such as Goings, as well as those whose subjects are still lifes or the human figure, rely increasingly on photographs rather than on direct observation or live models. Many of the most committed photorealist painters will slavishly copy photographs, changing not the slightest visual detail in the process. Others, however, will use the visual information from a number of photographs, altering details as they see fit, to create paintings that can be quite different from the original source material.

One might wonder why anyone would bother to produce a painting or drawing of an existing building when the purpose of architectural illustra-tion, as it is customarily defined, is to depict that which is not yet built. There are two answers. The first is that drawing and painting yield very different visual results than does photography. An individual artist or client may simply prefer, in a given situation, the look of a drawing to that of a photograph. To such people, a photograph is not an end in itself but rather a means to an end. The second answer is that a client may want to alter some of the information in a photograph. If a building is under construction and the builder and/or client cannot wait until completion for finished photographs, he or she may want an illustration showing what that building will look like in three months' time. Similarly, a client may commission an illustrator to produce a drawing of an existing building about to undergo remodeling or restoration. In such circumstances, it is almost always easier for the illustrator to work from photographs rather than to project a perspective line drawing from scratch.

Most architects and illustrators are not great photographers. We cer-tainly are not. Drawings we have done from photographs have always looked better than the photographs themselves. We use a 35mm camera and slide film when taking photographs. After choosing the slide from which we will work, we project the image onto a smooth wall using a slide projector. We then tape a piece of tracing vellum to the wall and make a freehand tracing of the image onto the vellum. From this tracing we make a second tracing in hardline. At this stage, we make any changes in the composition we feel are necessary, and decide how to crop the image. Finally, we take this hardline tracing, make a blueline print of it, and transfer it onto watercolor paper in the usual way.

Before we begin using watercolor, we have a good quality print made from the slide. The print allows us to see those details that are difficult to decipher from the small slide. The colors in a slide, on the other hand, are purer and brighter than those in a print. We use the slide rather than the print when making decisions about color composition.

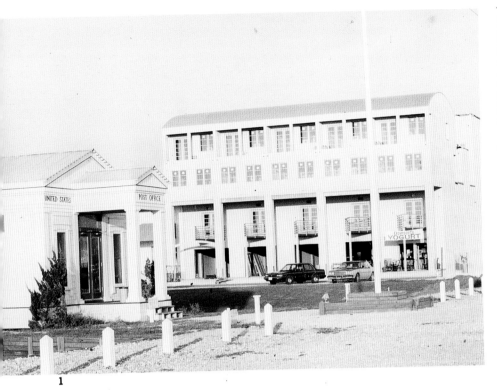

1

PROJECT:
Seaside Town Poster
Seaside, Florida

1. In this example, the client wanted a drawing based on this photograph. The building in the foreground, a post office, had been completed, but the one in the background was still under construction. The client wanted to make some changes in the existing post office signage, and to have the drawing indicate a paving material other than the gravel shown in the photograph.

Because the drawing was to be part of a series of drawings and would be greatly reduced, it was done at the relatively small size of 16″ × 16″. We decided that the style of the drawing should be like that of a sketch. We also decided to eliminate some of the unruly shrubbery near one corner of the post office, to pull the post office slightly to the left, and to severely crop the two-story building in the background. Although the photograph was of poor quality, it provided enough information from which to do a drawing.

2. The basic blue tones of the background building are established at this stage. The windows are painted with Prussian blue. Light washes of Antwerp blue distinguish the various wall planes of the upper floors, and purple is used for the shadows.

2

3. The shop windows and doors of the ground floor create the most difficult challenge. Because construction of this portion is not yet complete, and because the architect's elevation drawings are not available, what this area might look like has to be imagined. The grass in the background is added at this time, using a mixture of Prussian blue, raw umber, and yellow ochre applied in several graded washes. The shadow on the grass is painted on using Prussian blue.

4. The information on the post office provided in the photograph is quite complete, and it is therefore easy to finish this portion. The entry door appears quite sharp in the photograph and, as a result, is the most realistic element of the drawing. The clapboard on the post office is rendered a brighter yellow than it appears in the photograph, and shade and shadow on the white columns, pediment, and trim pieces are rendered in tones of ultramarine and purple.

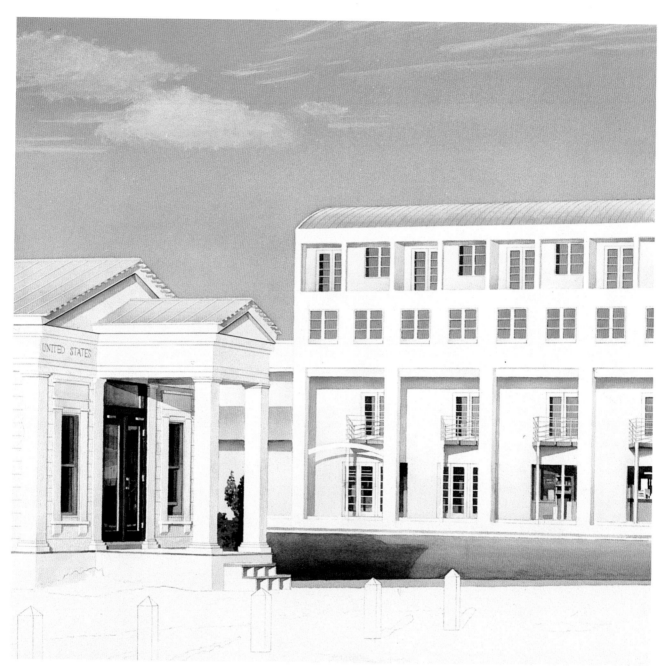

5. After the roofs have been masked with tape, the sky is painted Prussian blue. The value of the sky in the drawing is darker than that in the photograph. This is done so that the sky will contrast more sharply with the buildings. The clouds are added by dabbing Chinese white onto the drawing with a sponge. The roofs are painted in with graded washes of Antwerp blue. The seams in the roof are drawn in with a ruling pen.

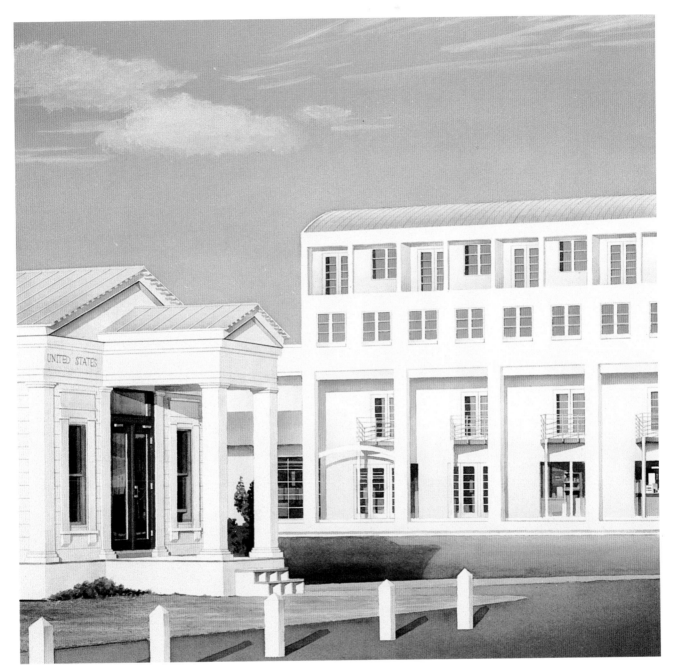

6. The drawing is completed when the paving, posts, and remaining grass are painted in.

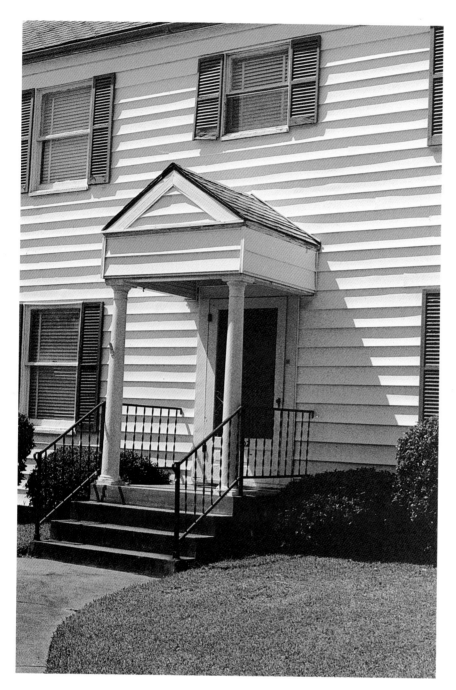

As with the previous example, this one is based on a photograph. Although the building in the photograph is insignificant architecturally, it is interesting because of the shadows; the horizontal shingles, the shutters, the window shades, and even the porch itself are all described by their shadows. To emphasize this, the original photograph is cropped on the sides to make a narrower image, focusing on the entry. Beyond that, however, and unlike the previous example, no other changes are made to the original photograph.

Because the building is white, it is the shadows that are painted first. Here, alternating washes of ultramarine blue and purple made of Prussian blue and alizarin crimson are used.

Next, the steps and sidewalk as well as the porch roof are painted with a wash of burnt umber, ultramarine blue, and alizarin crimson. Additional washes are used on the darker surfaces, and the part of the steps that is in shadow has a final wash of alizarin crimson, to deepen and enhance the color.

Although the shutters are a grayish green in the photograph, they are first painted here with a light coat of Prussian blue and a small amount of Hooker's green. A darker coat is then painted around the frame of the shutters, and used also for the shadows of the slats.

The grass and bushes are painted last. As in the previous example, the grass is painted with a mixture of Prussian blue, raw umber, and yellow ochre, applied in several graded washes. The bushes also receive a coat of this mixture, with a very dark wash of Prussian blue dotted over it to create the areas in shadow.

The drawing is completed when the black railings and porch roof shingles are drawn in with a ruling pen.

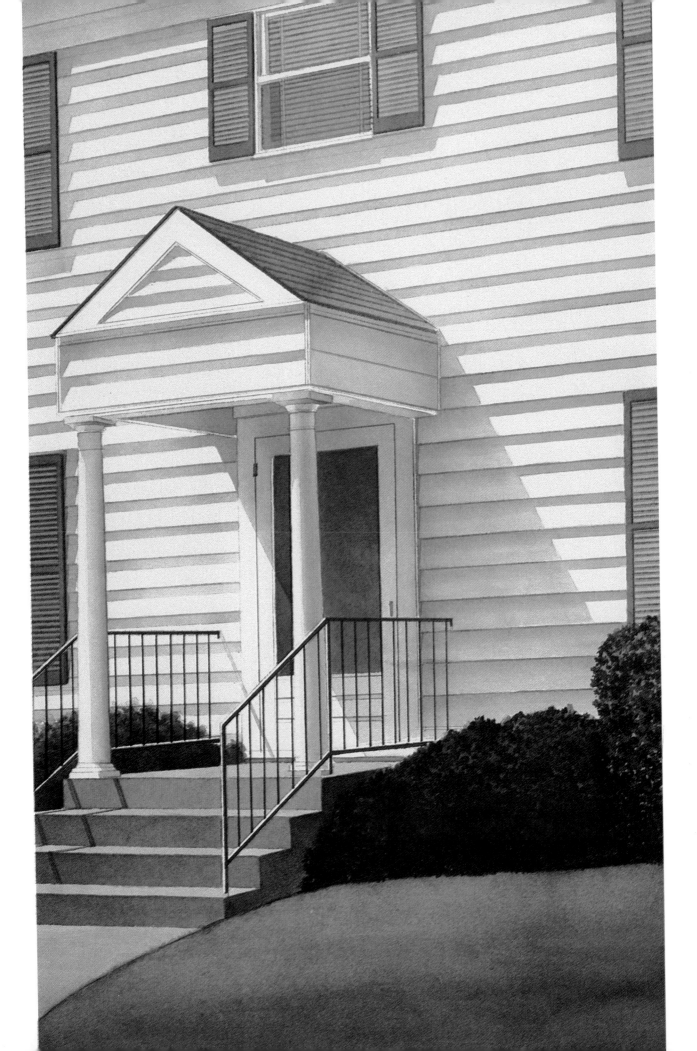

BIBLIOGRAPHY

Chase, Linda. *Ralph Goings*. New York: Harry N. Abrams, 1988.

Dorfman, Bruce. *Color Mixing*. New York: Grosset & Dunlap, 1967.

Doyle, Michael. *Color Drawing: A Marker-Colored-Pencil Approach*. New York: Van Nostrand Reinhold, 1981.

Drexler, Arthur, ed. *The Architecture of the Ecole des Beaux-Arts*. Essays by Richard Chafee, Arthur Drexler, Neil Levine, David Van Zanten. New York: The Museum of Modern Art, 1977, distributed by the MIT Press.

Hardie, Martin. *Watercolor Painting in Britain: The Romantic Period*. Vol. 2. Edited by Dudley Smelgrove with Jonathan Mayne and Basil Taylor. New York: Barnes & Noble, 1967.

Itten, Johannes. *The Elements of Color*, ed. Faber Birren. New York: Van Nostrand Reinhold, 1970.

Lever, Jill, and Margaret Richardson. *The Architect as Artist*. New York: Rizzoli, 1984.

Libby, William Charles. *Color and the Structural Sense*. Englewood Cliffs, N.J.: Prentice-Hall, 1974.

Lowry, Bates. *Building a National Image: Architectural Drawings for the American Democracy, 1789–1912*. New York: Walker, 1985.

Mallalieu, H. L. *Understanding Watercolors*. Woodbridge, Suffolk, England: Antique Collector's Club, 1985.

Munsell, A. H. *A Color Notation: An Illustrated System Defining All Colors and Their Relations by Measured Scales of Hue, Value, and Chroma*. Baltimore: Hoffman Brothers, 1947.

Nevins, Deborah and Robert A. M. Stern. *The Architect's Eye: American Architectural Drawings from 1799–1978*. New York: Pantheon, 1979.

Stamp, Gavin. *The Great Perspectivists*. New York: Rizzoli, in association with the Royal Institute of British Architects Drawing Collection, 1982.

Wilcox, Scott. *British Watercolors: Drawings of the 18th and 19th Centuries from the Yale Center for British Art*. Introduction by Patrick Noon. New York: Hudson Hills Press, in association with the Yale Center for British Art and the American Federation of Arts, 1985.

INDEX